ACRYLIC TECHNIQUES IN MIXED MEDIA

Layer, Scribble, Stencil, Stamp

Roxanne Padgett

NORTH LIGHT BOOKS
Cincinnati, Ohio
www.createmixedmedia.com

CONTENTS

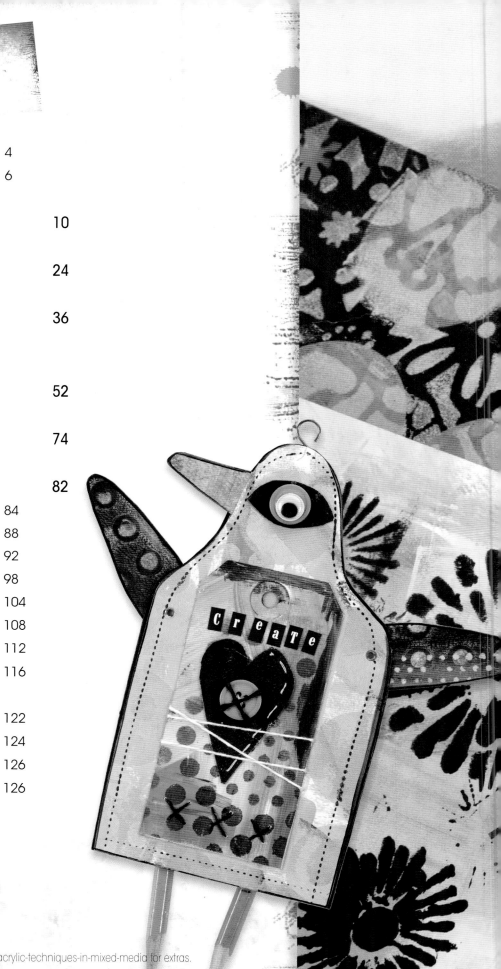

Recommended Supplies

The following is a list of supplies used throughout this book. Don't feel like you need to rush out and get them all at once. Get a few now. Get a few later. Experiment and find materials you like to work with.

- 9" polyester all-purpose zipper
- Acrylic paint
- Artists' crayons
- Awl
- Baby wipes
- Black and white copies
- Bone folder
- Brads
- Brayers
- Buttons or beads
- Canvas
- Clips
- Colored binder rings
- Colored tape
- Combing tools
- Computer
- Copic markers
- Corded black elastic
- Correction pens
- Cotton fabrics
- Craft knife
- Crayons
- Cutting mat
- Embellishments
- Embroidery floss
- Fabric
- Fabric sealant
- Fine-point permanent marker
- Gesso
- Glazing medium
- Gloss varnish
- Glue sticks
- Handheld drill and ¹⁄₁₆" (2mm) drill bit
- Hole punch
- Hot glue gun
- Iron
- Jump ring
- Kitchen sponges
- Large paper needle
- Large white paper plates
- Magazine pages
- Manila folders
- Matte medium
- Miscellaneous mark-making tools including pizza wheels, tracing wheels, kitchen gadgets, toys, packing and recycled materials.
- Needle
- Needle-nose pliers
- Paintbrushes
- Painter's tape
- Paper
- Paper cutter
- Paper towels
- Pencils
- Permanent adhesive address labels
- Permanent marker
- Pinking shears
- Plastic measuring tape
- Pliers
- Poster paint pens
- Punches, including tag-shaped punch
- Pushpins
- Ruler
- Safety pin
- Scissors
- Sewing machine
- Small golf pencils
- Small sponge rollers
- Stamping ink
- Stamps
- Stapler
- Stencil brushes
- Stencils
- Tacky glue
- Thread
- Transparencies, or overhead projector sheets
- Water container
- Wax
- White cosmetic sponges
- Wire
- Wooden circles
- Wooden clothespins

3

INTRODUCTION

It begins with color: a patch of red, a scribble of magenta, a splatter of orange. The colors express how I feel and think without saying a word. I continue painting: A drop of paint and an accidental spill add to the uniqueness of the piece. Stamping, rolling, stenciling, painting, building the layers that alternately reveal and conceal, creating combinations that I could not have expected. Let's collage some paper scraps and another layer of scribbled crayon lines. When do I stop? Get another piece of paper or canvas and see what happens—the possibilities are limitless.

As a child, I spent most of my time making "stuff" with items we had around the house. I didn't have many "real" art supplies; I had crayons, coloring books, scraps of fabric, scissors, tape, needle and thread. Simple media and techniques, like scribbling with a crayon, are still what I use most in my work. I am interested in using uncomplicated mediums and techniques to create multilayered works.

As a teaching artist, I have taught art classes to thousands of children and adults over twenty-five years. I have always been inspired by children's ability to play and experiment with color, materials and techniques. I believe everyone is creative, not just the special few artists. I encourage students, young and old alike, to experiment with and use simple techniques and materials. You don't need a lot of fancy art materials to create. You have enough, and are enough, right now to be creative, to explore, to play and to express yourself. My goal with this book is to give you the tools to do just that.

The opening chapter of this book, "Fear No Color," will walk you through the process of understanding color. Instead of painting a traditional color wheel, you can gain an understanding of color by painting sheets of paper. Each sheet can become background pieces for other techniques like mark making, stamping and stenciling.

The second chapter, "It's Elementary," will help you overcome your fear of the blank page. When was the last time you picked up a crayon and just scribbled on a big sheet of paper? It can release you from the idea of a perfect white canvas or page. This is just one of many layering techniques to add to your mixed-media "tool box."

The next two chapters focus on printmaking and painting techniques you can use on a variety of substrates, from paper products to textiles and painters canvas. Besides learning the techniques, you'll also learn to make your own stencils, stamps and collagraph plates. Creating your own tools will give your work uniqueness, and you will be able to get what you want when you want it; you can create it yourself with what you have.

Once you have played with the different techniques, you will put it all together in the "Layer It Lush" chapter. Experiment with how these techniques work together, mix and match techniques and color combinations, encourage mistakes and see what emerges.

By now you will have several pieces of fully layered lush paper and textiles that can be used for the eight projects. You will learn to create these projects step-by-step in the final section of the book. Create items that are uniquely yours and functional, including business cards, journals and even zippered bags.

Through playing and experimenting with these materials and techniques, your own personal style will emerge. Make mistakes, embrace them and keep going. Mistakes can be a doorway for unexpected discoveries, so leave your eyes and mind open for new opportunities you can build on. In the end, it is only a piece of a paper or cloth. You can always add another layer.

TOOLS AND MATERIALS

To create my art, I use everyday materials that are easily accessible and inexpensive. I like to see how far I can push my materials to express my ideas. I would encourage you to purchase a few materials to begin with, experiment with them and see what works for you. In the beginning, all you really need are some primary colors of paint, matte medium, a few crayons and a piece of paper or canvas.

Paint

There is a wide variety of paints that can be purchased at art and craft stores and online. I primarily use acrylic paints. Acrylics come in a huge variety of colors, the paint dries quickly and they are easy to clean up. I like the color and quality of Liquitex and Blick basic paints.

Paint Mediums

There are many additives or mediums that can change the nature of how paint acts, from slowing down the drying time to thickening or thinning the paint without losing the pigment quality. I always have gesso and matte medium on hand for my mixed-media projects.

- **Gesso:** A primer for substrates, including canvas, that you paint on as a base for painting and other mixed-media techniques. I use it on printed cottons and paper to change the surface quality. You can paint gesso in random areas of a substrate to create unexpected effects.
- **Matte medium:** Can be used to extend paint, increase translucency and can decrease sheen, if desired. I also use matte medium to adhere collage elements to my mixed-media projects.

- **Glazing medium:** Slows the drying time of acrylic paint; I use this for my Paint Combing technique (see the "Stenciling and Painting Techniques" chapter).
- **Gloss varnish:** Adds a shine to the surface of a piece. I also use it as a protective coating on items that will get a lot of use, like one of my painted bags.

Painting Tools

I love to keep all my painting tools sorted by type for easy access. I look for tools that I can use for painting everywhere I go: thrift shops, garage sales, grocery stores and discount stores as well as at art stores. I can do many of my painting projects without ever picking up a paintbrush. White cosmetic sponges are one of my staples for painting and collaging, as are inexpensive foam rollers for stenciling.

- **Paintbrushes:** I buy brushes in a variety of sizes and types. Most of them, including Liquitex, are inexpensive. I also like the 1" (25mm) wooden brushes from hardware stores for painting larger sections of my pieces.

- **Stencil brushes:** With a flat bottom, these work well for most of my stenciling. I also like the foam stampers; these are round sponges attached to a wooden handle.
- **White cosmetic sponges:** One of the most versatile painting tools, in my opinion. You can use them for stenciling and painting, or you can use them like a stamp pad to apply paint to stamps and other printing tools. The sponges are inexpensive and can be washed out and used again.
- **Small sponge rollers:** Great for stenciling on large stencils and can be purchased at art and craft and hardware stores. Look for rollers that have a tight hole pattern on the sponge.
- **Kitchen sponges:** I use them to keep my area clean while I paint, but I also wipe my paintbrushes off with a sponge to keep them clean when I am color mixing.
- **Stamps and stamping materials:** There are a variety of stamps that can be found at art and craft sources. The stamps can be made of rubber, foam or acrylic. You can easily create your own stamps with fun foam (see the Creating Foam Stamps technique in the "Printing Techniques" chapter). When I use ink with my stamps, I use permanent ink pads that can be re-inked from a refillable ink bottle. But most of the time, I apply acrylic paints with sponges to my stamps.
- **Stencils:** I use many different stencils in my work, purchased, found and some created by myself.
- **Combing tools:** You can purchase combing tools made for use with paste paper. I also use regular hair combs, hair picks and plastic forks. You can cut your own from cardboard (see the Paint Combing technique in the "Stenciling and Painting Techniques" chapter).
- **Miscellaneous tools:** I also use a variety of tools that are not meant for painting but are great for mark making and printing: pizza wheels, tracing wheels, kitchen gadgets, toys, packing and recycled materials.

Brush Care

Clean brushes in warm soapy water after use, but do not leave them soaking in a water container. Brushes will last for years if you take care of them.

Substrates

You can use the techniques in this book on just about any surface that is somewhat flat. I keep a variety of different fabrics, canvases and papers on hand. I work on several different substrates at once; each will have a unique response to the techniques and materials used. I most commonly use lightweight canvas and drawing paper.

- **Canvas:** I use all kinds of canvas for my painting. You can purchase canvas by the yard or prepackaged at art supply stores and online. You can buy the canvas already primed with gesso or unprimed; I usually work with unprimed. I also purchase canvas at the hardware store that is actually used to protect your floors when you are painting your walls. This canvas is a bit rougher, but I like the texture.
- **Cotton fabrics:** I love 100 percent natural cotton linen. It has a wonderful texture and keeps its softness even after painting. It sews great on a sewing machine or by hand. Cotton duck fabric comes in a variety of solid colors and has a tight weave. Cotton prints come in a variety of patterns and are fun to paint on. I encourage you to use old fabrics you already have or cut up old clothes to paint on. Sometimes the ugliest pieces of fabrics, once layered, turn out to be my favorite pieces.
- **Paper:** My favorite paper for mixed-media work is 80 lb. drawing paper in cream or white. This paper can be purchased in large tablets and cut up for book pages or mixed-media layering. I also use copier paper, magazine pages, text pages from books, manila folders, envelopes, paper bags and a variety of paper ephemera.

Adhesives

I use glue sticks and matte medium for most of my gluing and collage work. A hot glue gun works as an occasional, temporary fix.

- **Glue stick:** The only one I use is UHU; it's of good quality and is acid-free.
- **Tacky glue:** For gluing heavier objects. You can use the applicator tip or brush on with a glue brush.
- **Hot glue:** Occasionally I use a small amount of hot glue, from a glue gun, to hold things in place.
- **Fabric sealant:** Keeps the edges and ends of fabric and canvas from fraying. Brands such as Fray Check can be purchased in the sewing department. It also works on stitched lines on paper.
- **Painter's tape:** Used to hold pieces of canvas and fabric together for sewing instead of straight pins. And I love tape used as a decorative element in mixed-media projects.
- **Thread:** All-purpose colored threads work best for sewing with a sewing machine and by hand. Metallic threads can be used for decorative touches. I use 6-strand embroidery floss to bind my books and for decorative stitching lines.

Drawing Materials

My favorite drawing materials are regular crayons that have had the paper peeled off and a no. 2 pencil. But I have to try all the different drawing pens and pencils that are out there, too. I buy one or two to experiment with before I buy more of them.

- **Crayons:** Regular children's crayons are one of my favorite mediums. I like to buy the chubby crayons, peel the paper off and use in rubbings or scribbling.
- **Artists' crayons:** You can't beat the pigment quality of artists' crayons; their colors are bright, bold and intense. I use Caran d'Ache Neocolor crayons. They are great for adding layers of colors, and because they are water-soluble, when you add water, they become like paint. They are expensive but worth every penny.
- **Pencils:** Regular no. 2 pencils and colored pencils.
- **Sharpies:** Regular fine-tipped black and Sharpie Poster Paints are what I use the most in my work.
- **Copic markers:** High-quality markers that come in a large variety of colors. They have different tip sizes, and they work well on painted surfaces.
- **Correction pens:** Meant for making corrections, they work great for making scribble lines and writing on painted mixed-media surfaces. I use the Wite-Out brand.

Tools

I find good quality cutting tools invaluable, and I have several paper cutters of different sizes. I will use these to cut paper, fabric and canvas. But I will use items around the house, such as pushpins, for making holes or painter's tape for holding canvas in place. I like to improvise and will try anything to get the job done. Don't be afraid to experiment and play with your tools and materials.

- **Bone folder:** A tool used by book makers to fold pages and score lines in paper.
- **Scissors:** Large, fine-tipped and pinking shears. I try to buy the best quality scissors I can afford; with proper care they will last a lifetime.
- **Paper cutter:** I have a small cutter on my work surface for cutting small pieces of paper and scraps. But I have a very large, sharp guillotine paper cutter that I use for very thick mat board, painted canvases and papers.

- **Craft knife and cutting mat:** You can buy craft knives with interchangeable blades. Be sure to use these on a cutting mat to avoid cutting up your work surface.
- **Awl or pushpins:** Awls are used for making holes in paper and making holes for spines and pages of a book. I use pushpins to create smaller-sized holes for binding pages.
- **Clips:** I use a variety of clips for holding pages in place. Paper clips, binder clips and wooden clothespins are all handy to have.
- **Pliers:** I use needle-nose pliers for small projects, such as attaching wire and beads to projects.
- **Sewing machine:** Because I sew through painted and mixed-media layers, I have an inexpensive heavy-duty sewing machine that does not do a lot of fancy stitching. I don't want to use a machine that costs thousands of dollars to be sewing through paint and glue. I have a Singer model that cost a few hundred dollars and can sew through several painted layers.
- **Brayers:** These are usually used for spreading ink or paint for printing projects, but I use them to flatten out projects or to secure collage elements to a surface.
- **Punches:** I use a variety of hand punches for making holes, shapes and tags that I can use for mixed-media projects.

FEAR NO COLOR

Color is definitely my thing. I notice color first, whatever the object might be: shoes, a car, a flower, a piece of art. We can all relate to color aesthetically, emotionally, scientifically and through our subconscious. We respond to color in different ways, and we know what we like and don't like. When I am teaching a class or workshop, I might have a student feeling frustrated because she can't mix the color she imagines in her head. Understanding the basics of color will give you the tools to create those colors in your imagination. That is not to say that I begin every project knowing exactly what colors I will be using. Usually I begin with one or two colors in mind and go from there. Understanding color is a tool I choose to use or not. Fear no color! Experiment and play—remember, it's only a piece of paper!

Visit www.createmixedmedia.com/acrylic-techniques-in-mixed-media for extras.

11

THE COLOR WHEEL

Color theory can be learned through the use of a color wheel, a tool used by many artists. The basis of the color wheel comes from Sir Isaac Newton's work on the light spectrum. If you go online to find a color wheel chart, you will notice many variations. Which one should you choose? I suggest you create your own color wheel, using the brands and colors of paint you like. You may think, why should I learn to mix my own colors when I can go out and buy any color of paint I want? We can all look at a color wheel and understand how colors are created in theory; in our minds, we understand it. But to fully understand how colors are made and used, we need to practice it in real life. We need to have the physical experience of color mixing to have a deeper understanding of how colors work and play together. Then we can apply these theories to our work and what we want to express. My best advice is to know what the rules are and then break them when you choose.

This piece is a heavyweight canvas painted with a color wheel design and embellished. It was then sewn onto the cover of this mixed-media art journal.

COLOR BASICS

Using these basic elements of color, you will paint sheets of paper that mimic the color wheel, or start pieces using tints and shades. These exercises will help you understand how colors work together. Later on, you'll be able to incorporate this basic information to create projects in any color combination you wish.

- **Primary colors** are red, yellow and blue. In theory, you can create all of the colors in the color wheel with the three primary colors. For my color wheel, I use primary yellow, magenta instead of red and cyan or turquoise blue instead of Ultramarine Blue.
- **Secondary colors** are orange, green and violet or purple. These are created by mixing the primary colors together. When referring to purple, I will be using the word *violet*.

 > yellow + red = orange
 > yellow + blue = green
 > blue + red = violet

- **Tertiary colors** (or intermediate colors) are yellow-orange, red-orange, red-violet, blue-violet, blue-green and yellow-green. These colors are created by mixing a primary and a secondary color together. When referring to these colors, use the primary name first.

 > yellow + orange = yellow-orange
 > red + orange = red-orange
 > red + violet = red-violet
 > blue + violet = blue-violet
 > blue + green = blue-green
 > yellow + green = yellow-green

- **Analogous colors** are closely related to each other because they have one hue in common (hue is another word for color). These colors appear next to each other on the color wheel. For example, blue, blue-violet and violet all contain the color blue. When you use analogous colors together, they create a harmonious quality.
- **Complementary colors** are opposite from each other on the color wheel, for example, red and green, orange and blue or yellow and violet. When you place complements next to each other, they produce a strong contrast or pop! When you mix complements together, you get browns or mud.
- **Tints and shades** are hues that are created by adding black or white paint to a single color or hue. Adding white to a color lightens the color and is called a tint. For example, adding white to red makes pink. Adding black to a color darkens the color and is called

This color wheel uses the hues of paint I like to create colors with: primary yellow, magenta and cyan blue. The lines connect the primary colors and connect the secondary colors. Tertiary colors are in between them.

a shade. When tints and shades are used together in a composition, using only one hue, or color, it is called a monochromatic color scheme.

 > color + white = tint
 > color + black = shade

- **Warm colors** are associated with yellows, oranges and reds.
- **Cool colors** are associated with greens, blues and violets.
- **Neutral colors** are not associated with a hue. Black, white, grays and browns are considered neutral. These colors are theoretically neither warm nor cool. Some neutral colors are achieved by mixing complementary colors that neutralize each other.

PAINTING COLOR WHEEL PAGES

Rather than painting a traditional color wheel, you can paint sheets of paper to add to your stash of painted papers. You can use the papers as the start of a project or cut them up and use them in various projects. I like to keep many of these color wheel papers in my stash to pull out at any time for mixed-media projects.

My color wheel is based on the combination of colors I like to paint with: primary yellow, Quinacridone Magenta and Cerulean or cyan Blue. These colors may or may not work for you; I encourage you to experiment with different hues and brands of paint.

MATERIALS LIST

- 12 sheets of drawing or watercolor paper
- Acrylic paint in primary yellow, Quinacridone Magenta and Cerulean or cyan Blue
- 1 " (25mm) paintbrush
- Water container
- Sponges or paper towels
- Large white paper plate

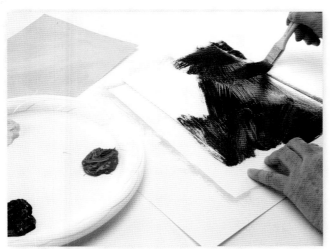

1 Pour the three primary colors of paint on a large white paper plate. Using the paintbrush, paint a sheet of paper with each of the primary colors: yellow, magenta and cyan blue. Clean your paintbrush in water after every color change throughout this process.

2 Use your paintbrush to scoop up a large amount of yellow paint and place it between the yellow and magenta paint on your palette. Mix a small amount of magenta into the yellow and mix the two colors to make orange. Paint a sheet of paper orange.

Paper Plates for Palettes

I use large white paper plates for my paint palettes. By using the white paper plate, I can clearly see the colors of paint. I don't like wasting paint, so instead of washing a plastic paint palette out when I am done, I save the painted paper plates and use them as collage elements in other projects.

Mixing Tip

Make sure you mix enough of your secondary colors so you will have enough to mix the tertiary set of colors.

3 Use your paintbrush to scoop up a large amount of yellow paint and place it between your yellow and blue paint. Mix a small amount of blue paint into the yellow to create green. Paint a sheet of paper green.

Use your clean paintbrush to scoop up a large amount of magenta paint and place it between your magenta and blue paint. Mix a small amount of blue paint into the magenta to create violet. Paint a sheet of paper violet. Now you have three sheets of primary colors and three sheets of secondary colors.

4 Start mixing the tertiary or intermediate colors. To create yellow-orange, mix between the yellow and orange paint on your palette. Paint a sheet of paper yellow-orange.

To create red-orange, mix between the red and orange paint, and then paint a sheet of paper red-orange.

To create red-violet, mix between the red and the violet paint, and then paint a sheet of paper red-violet.

To create blue-violet, mix between the blue and violet paint, and then paint a sheet of paper blue-violet.

To create blue-green, mix between the blue and the green paint, and then paint a sheet of paper blue-green.

5 To create yellow-green, mix between the yellow and the green paint, and then paint a sheet of paper yellow-green. With that final color, your color wheel is complete.

Textured Brushstrokes

To create textured brushstrokes, dip the paintbrush in water while painting and continue painting. You can also wipe some of the paint off the surface of the paper with a paper towel for a textured look.

Color Wheel Ideas

Instead of sheets of paper, consider painting the colors of the color wheel on small paper tags. When the tags are dry, place them together with a paper fastener through the hole on the tags. Now you have a mini color wheel.

Fold a long strip of drawing paper into an accordion fold that has twelve sections. Paint each of the sections with each of the colors of the color wheel. You could even use this as the start of an art journal.

MIXING BROWN, OR HOW TO AVOID "MUD"

Usually when I teach a painting class, at least one person is frustrated because her painting is turning brown when she doesn't want it to, or as I say, "becoming mud." There may be times when you will need to mix a brown, but if you don't want mud in your painting, you need to know how to avoid it. Any time you mix colors that are across from each other on the color wheel (complements), you will create a brown or neutral. When you are working in layers on your mixed-media pieces, make sure each layer is dry before you add a color that is opposite from the color you are working with. You can speed up the drying process by using a blow dryer.

MATERIALS LIST

- Paper, canvas or fabric substrate
- Acrylic paints in primary yellow, Quinacridone Magenta, Cerulean or cyan Blue
- Paintbrush
- Water container
- Sponges or paper towel
- Large white paper plate

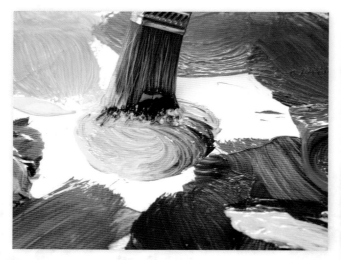

1 Choose two colors that are across from each other on the color wheel: blue and orange, red and green or, in this case, yellow and violet.

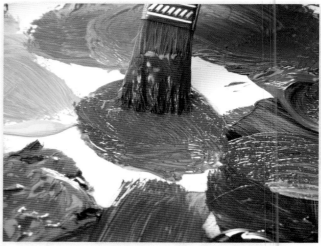

2 Mix the colors on your palette to create brown. Paint a sheet of paper brown.

Visit www.createmixedmedia.com/acrylic-techniques-in-mixed-media for extras.

On this page, I used a photocopy of a child's essay with brown made from red and green.

This brown was made from orange and blue on a photocopy of lined paper with scribbles.

The first piece of paper was painted yellow and allowed to dry. Then, stenciling with purple paint was done on top and stamped with a foam stamp using a tint of purple.

This piece of paper was painted yellow and then before the piece was dry, I stenciled purple paint on top. As you can see, the colors mixed and made a brown color or what I call "mud."

PAINTING TINTS AND SHADES

Tints and shades used together in a composition using only one hue, or color, creates a monochromatic color scheme. Monochromatic color schemes are lacking in contrast, which is why I start many of my canvas or paper pieces in this way. I can add layers of contrasting elements later on if desired. Adding tints and shades will give you a larger range of colors with which to create a richness of hues in your projects.

Creating Color Gradients

To create graduated color on a piece of paper, you don't even need to use a palette. Using a 1" (25mm) paintbrush or a small foam roller, begin painting with one color of paint on a sheet of heavy drawing paper. To mix a tint, or to lighten the color, begin adding a small amount of white paint to the color and blend and paint on the sheet of paper. Continue adding white and blending until the paper is finished.

To mix a shade, or to darken the color, use the same process as above, but add black paint instead of white paint to any color.

This is a lightweight cotton fabric painted in tints and shades of blue.

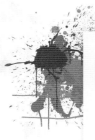

MATERIALS LIST

- Paper, canvas or fabric substrate
- Acrylic paints in one color and ivory or Titanium White
- Paintbrushes
- Water container
- Large white paper plate
- Crayon or pencil

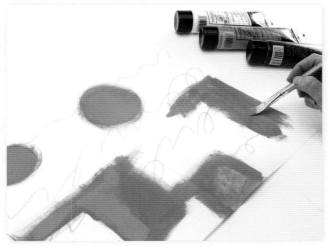

1 Using a crayon or pencil, scribble on a piece of canvas. Pour a color of paint on a palette; in this example I used light green, plus black and white. Begin painting random shapes on the canvas with the original color of paint.

2 Begin adding the white to the green paint and continue painting shapes and lines.

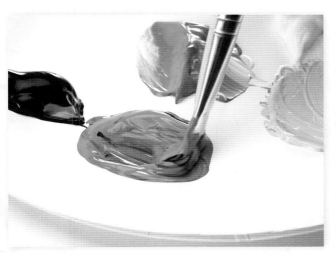

3 Wash the brush and add black to some of the green paint. Be light-handed with the black when you are creating a shade. You can always add more black, but it is much harder to go back to light after you have created a darker shade.

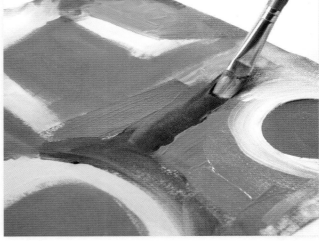

4 Continue filling in the canvas.

CHOOSING A COLOR PALETTE

At first, the process of choosing a palette might mean playing and experimenting with different colors. Try this exercise in several combinations of colors to see how colors work and play together. When you find a combination that appeals to you, you can create other projects with that color combination in mind.

Once you have some favorite combinations, the next time you start a new canvas, think about the attitude or tone you want to convey in a piece. Will you use analogous colors that create a calming effect? Or will it be a complementary palette that will have some energy or pop?

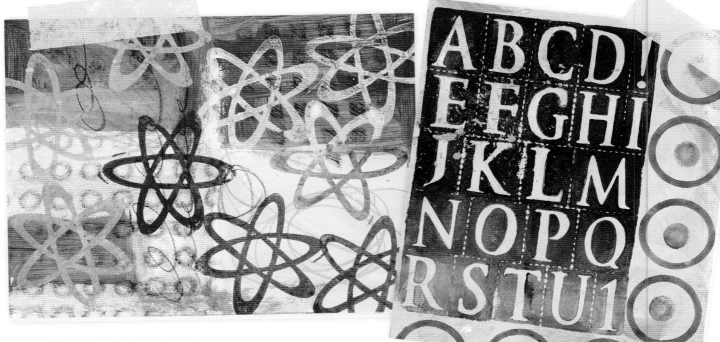

This is an example of an analogous color scheme using yellow, orange and red.

On this paper, I used a complementary color scheme of yellow and purple.

A Neutral Palette

Your palette can also be a neutral one, which makes for a great first layer. I used a neutral tone palette as a beginning layer in the Painted Canvas Altered Book project later in the book. For this piece, I started with black crayon scribbles and collaged on torn pieces of sewing patterns. I added white and Titan Buff paint. Finally I splattered yellow oxide across the surface by loading a toothbrush with watered-down paint and running my thumb over the bristles.

MATERIALS LIST

- Paper, canvas or fabric substrate
- Acrylic paints
- Paintbrushes
- Water container
- Large white paper plates

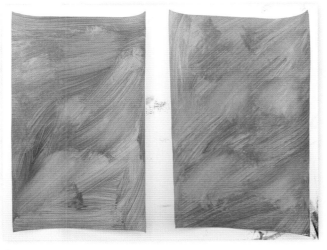

1 Paint two pieces of paper the same color; I used cyan blue for this one.

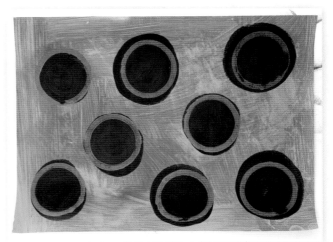

2 After the paint is dry, choose an analogous color of paint (deep violet, in this case) and paint circles on top of the paper. Add white to create a tint of the analogous color and loosely outline the circles for interest.

3 With the other sheet of paper, choose the color that's complementary to the background (in this case, orange) and paint circles on top of the paper. Add white to create a tint of the complementary color and loosely outline the circles for interest.

Let It Dry

Let each layer of paint dry thoroughly before adding the next layer. I use a blow dryer to speed up the process. I don't use a heat gun, as that will curl the paper or peel off the paint. If you don't let it dry between layers, you may get mud!

IT'S ELEMENTARY

A white piece of paper—the blank slate—can be more frightening to some than a nightmare. If you stare at a white sheet of paper for too long, you can become paralyzed with how you are going to fill the space. I begin most all of my projects with a scribbled line. It takes away the idea that the white surface is precious, and I like the visual energy of the line. You can also begin your pieces with some type of grid design, a large wash of color or collage pieces. All of these methods can take away the fear of the blank page and help you organize your layering process.

MAGAZINE PAGE AS SUBSTRATE

Magazine pages make wonderful substrates for mixed-media collage. Using a magazine page takes away the pressure of the clean white surface. When I am purchasing a magazine, I look at the images and color, but I also consider the weight of the paper, as I like paper that's a bit heavier.

MATERIALS LIST

- Magazine pages
- Acrylic paints
- Caran d'Ache Neocolor crayons
- Paintbrushes or sponge

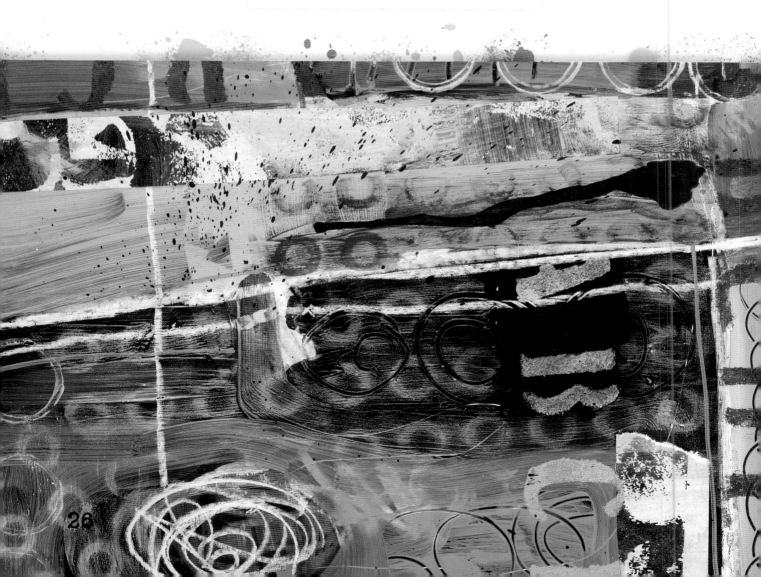

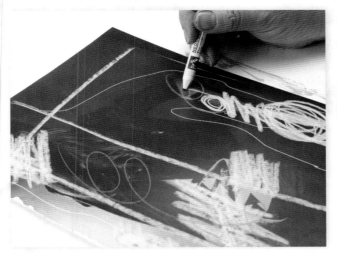

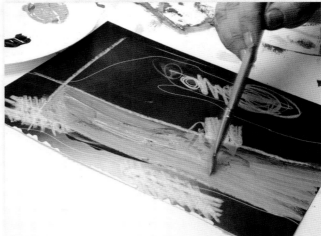

1 Scribble or draw lines with a crayon on a magazine page. Sometimes I like to make an informal grid on the page to start.

2 Using a sponge or a paintbrush and acrylic paint, begin painting in selected areas. I used yellow oxide, magenta and light blue-violet.

What to Do Next

These mixed magazine pages can be cut up for collage and book-making projects.

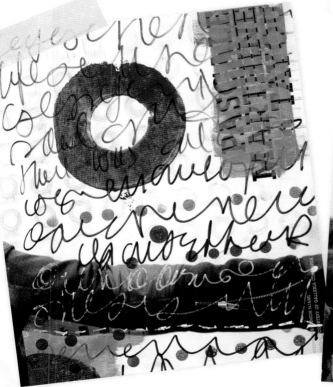

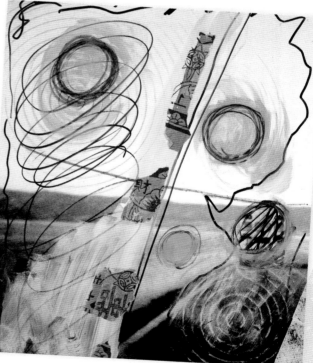

This is a magazine page with an image of a person's arm altered with acrylic paint, crayon rubbings and black permanent marker, and white correction pen marks.

I used acrylic paint, crayon rubbings, black permanent marker marks and collage over a magazine page with an image of a landscape.

BLACK-AND-WHITE COPIES AS SUBSTRATE

One of my favorite things to begin layering on is black-and-white photocopies. You can use your own artwork, old photos, paper you've scribbled on or just about anything you can fit on your scanner to create them. Make multiple copies of each to use in a variety of mixed-media projects.

Copy Collection

I have a collection of black-and-white copies that I use over and over in my artwork. I keep several copies on hand and keep the originals in a binder to make more copies as needed.

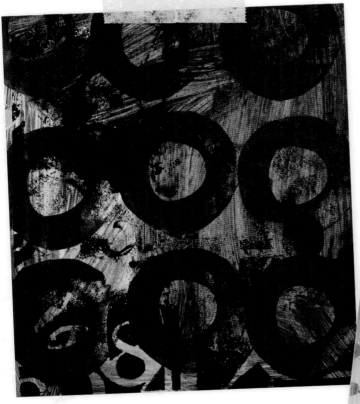

The completed piece from the steps at right to which I've added red paint and foam stamped circles.

This one is a black-and-white copy of numbered lines with acrylic paint, crayon rubbings, foam stamped numbers and rubber stamped words.

MATERIALS LIST

- Black-and-white copies
- Acrylic paints
- Paintbrushes or sponges
- Baby wipes or paper towels
- Matte medium

1 Take an original piece of artwork and scan it into your computer. Change it into a high contrast black-and-white copy. You can also manipulate your artwork on some copy machines or use a computer program like Adobe Photoshop. Make several copies of these.

2 Use matte medium to thin the acrylic paint. With a sponge or brush, wipe the thinned paint onto the copy.

3 With a baby wipe, wipe off selected areas of paint.

4 Continue painting and wiping until you get the desired effect. For this project I used Cadmium Red, primary yellow and Cadmium Orange. After the paint is dry, several techniques can be added to create layers, including stamping, stenciling, drawing and collage.

MARK MAKING

I usually begin and end all of my mixed-media pieces with mark making. I like to start a piece with scribbled lines or make a grid or a grid like design. For the last layers, you can add small detail marks or another layer of color with drawing materials. We all love to collect different kinds of markers, pens and pencils, but you can make marks with lots of other types of materials. Here are some examples.

MATERIALS LIST

- Paper, canvas or fabric substrate
- Pencil
- Crayons
- Colored pencils
- Acrylic paints
- Paintbrush
- Needle and embroidery floss
- Tracing wheel

In this piece, I painted a sheet of lined paper, then made lines with a no. 2 pencil.

I made marks with colored pencils on this sheet of painted paper.

Visit www.createmixedmedia.com/acrylic-techniques-in-mixed-media for extras.

This is a painted canvas with marks made
with hand-stitching.

Make More Marks

Other items you can use to make marks include:
- children's crayons
- water-soluble crayons
- permanent markers
- poster paint markers
- correction pens
- sewing machine and thread
- pizza cutter
- puff paint
- paint spatter from brush

This is painted paper with marks made
with paint and paintbrush.

Painted paper with marks I made with
a tracing wheel (see next technique).

DEFINING SECTIONS

I begin some of my pieces by creating sections or grids. These sectioned areas can remain as part of the finished design or disappear as you add more layers.

MATERIALS LIST

- Substrate of your choice
- Acrylic paint
- Paintbrushes
- Large white paper palette
- Water container
- Large brush or foam roller

This is a finished piece from the sidebar at right using cotton print fabric with acrylic paint, stenciled circles and black lines using a pizza cutter (the solid lines) and a tracing wheel (the dashed lines).

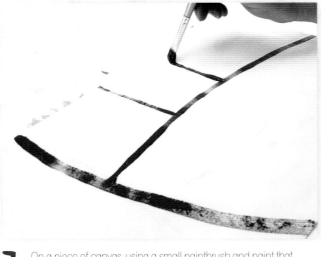

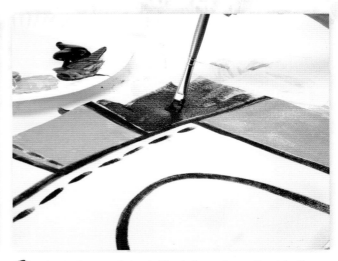

1 On a piece of canvas, using a small paintbrush and paint that has been thinned down with water, paint lines to create sections or shapes.

2 After the lines are dry, begin filling in the sections with paint with a larger brush or a foam roller.

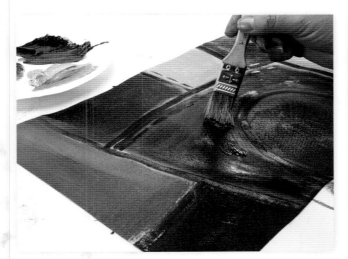

More Ways to Make Sections

There are many ways to create the sections on your substrate. Use a pizza cutter or a tracing wheel to create the lines (running the wheel through paint on your palette and then onto the surface, as shown below). Tape sections and remove the tape after painting. Draw with crayons or permanent markers. Or randomly paint in large sections with neutral colors.

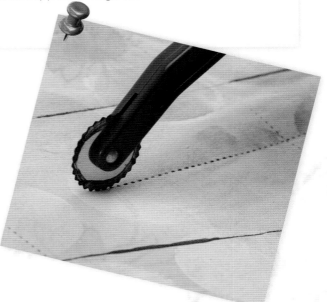

3 As you paint the sections, thin the paint with water to create varying degrees of translucency. Continue until the piece is completed. You may want to leave some areas unpainted.

Smoothing Canvas

I like to iron the canvas or fabric at the beginning and throughout the process to keep a smooth surface. Make sure the canvas is dry before ironing.

Sometimes I like to begin a piece with collage instead of paint. I like the way some of the text or images can show through the layers. Old sewing pattern pieces and tissue paper are among my favorite papers to use because of their translucent quality. This collage process is the same for paper or textiles. You add collage elements at any point in the layering process.

MATERIALS LIST

- Paper, canvas or fabric substrate
- Collage materials such as black-and-white copies, magazine pictures, painted papers, sewing pattern pieces and/or tissue paper
- Matte medium
- Paintbrush
- Scissors
- Optional: brayer

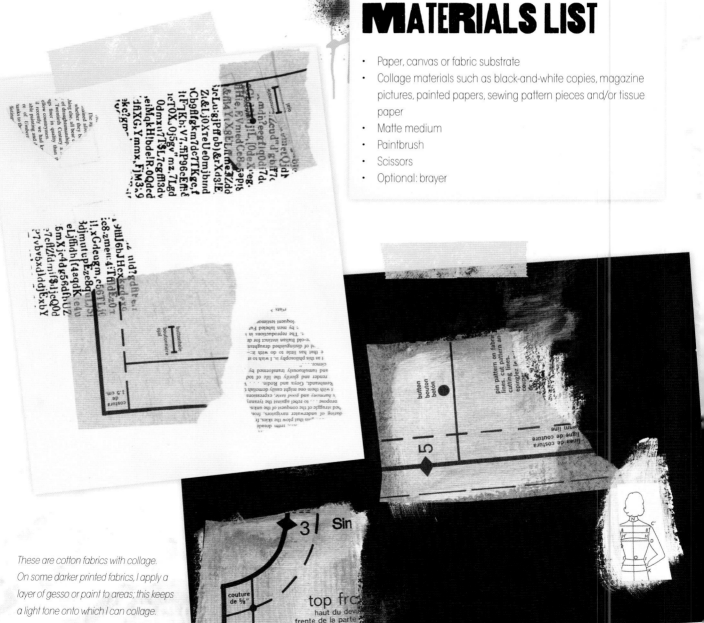

These are cotton fabrics with collage. On some darker printed fabrics, I apply a layer of gesso or paint to areas; this keeps a light tone onto which I can collage.

Avoiding Bubbles

If air bubbles occur, use a brayer to flatten out the air bubbles before the piece completely dries.

1 Use a paintbrush to apply matte medium to the area of the substrate you want to collage. Tear or cut the collage material into pieces and lay them on top of the wet matte medium. Brush matte medium over the top of the collage material to adhere.

This is a magazine page with orange collage squares that was painted. Then the paint was combed to add texture.

This is a piece of canvas with pencil lines that was collaged with pieces of a torn black-and-white copy.

PRINTING TECHNIQUES

Printmaking is a technique used for making repeated images and patterns. It's an easy and inexpensive way to add character and uniqueness to your mixed-media pieces. You might remember using a carved potato and tempera paint to stamp simple shapes over and over as a child. While we're not using potatoes, the printmaking techniques in this book are inspired by the projects I have done in my children's art classes. They are very easy, and you can create new designs at any time. I like to challenge myself to see how I can use simple materials and techniques to create lush and complex finished pieces.

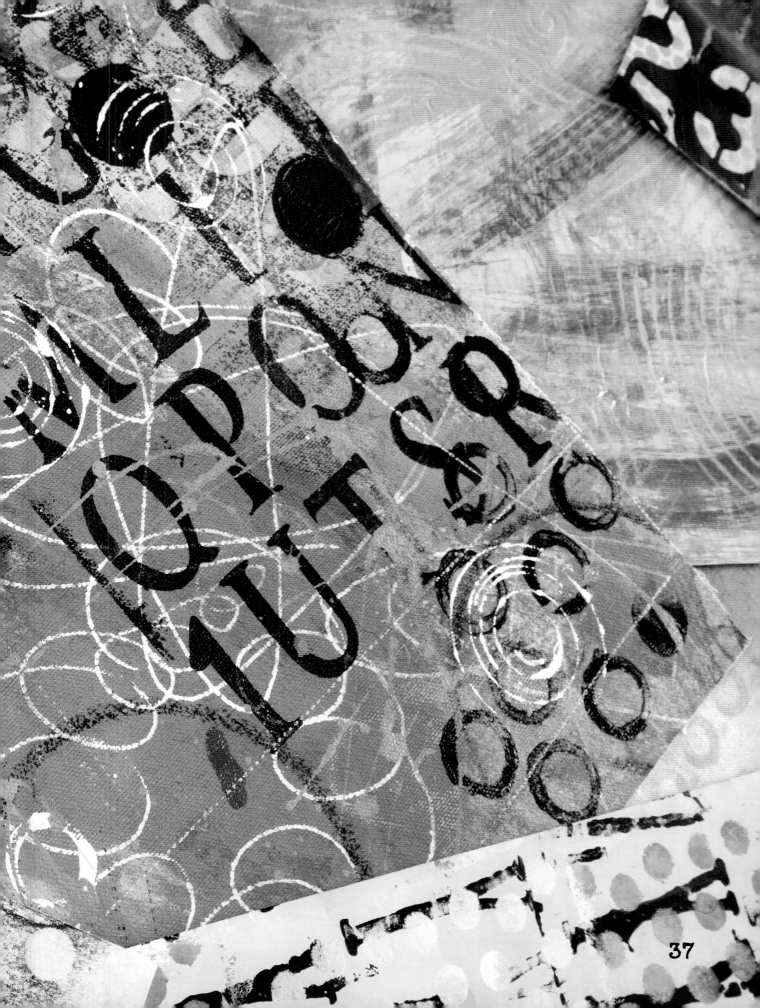

CRAYON RUBBING

Crayon rubbing is a form of printmaking and is one of my favorite techniques. You simply rub a crayon over the surface of a piece of paper or fabric that is overlaid on a textured object or plate. You can purchase texture plates from art stores, but I like hunting for textures in everyday objects. When I create rubbings, I use the large crayons intended for small children and peel the paper off. I have a large tray of "naked" crayons in my studio next to my workspace. You can use this technique as a beginning or final layer. Keep in mind, because you are using wax crayons, the paint may pool around the crayon marks to create a resist-like effect.

MATERIALS LIST

- Painted or unpainted paper, fabric or canvas
- Found objects or texture plate
- Large peeled crayons

A magazine page was painted with blue paint, crayon rubbing of circles and a spatter of paint.

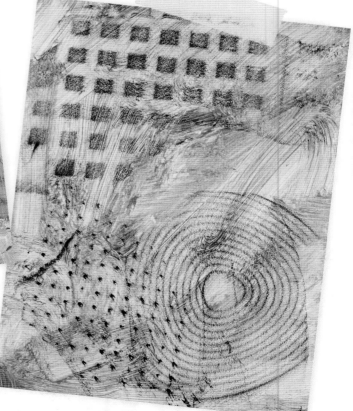

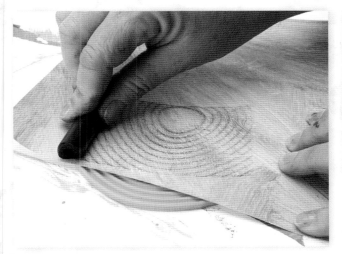

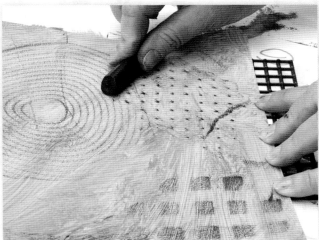

1 Lay a piece of paper or fabric over a textured object. Use one hand to hold onto the substrate; use the other hand to hold the crayon sideways and rub across the surface of the substrate.

2 Add several layers of rubbing as desired.

Finding Textures

Look for found-object textures everywhere you go. Consider plastic grids from the hardware store or kitchen sink mats, placemats and trivets from the dollar store. Nature provides texture in abundance, too. Try rubbings from leaves, feathers or tree bark.

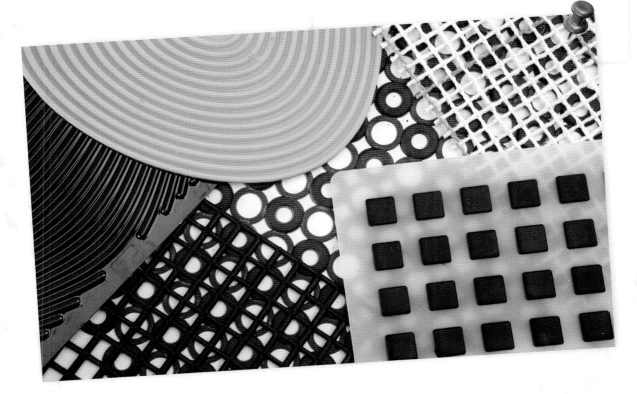

CREATING COLLAGRAPHS OR RUBBING PLATES

When you make a collage and create a crayon rubbing of that collage, this is called a collagraph. The collage that you make is the rubbing plate, and you can use this collage plate over and over to make crayon rubbings. The rubbing is basically a print of the collage. These print plates are quick, easy and inexpensive to make, and you can add lines, shapes, text, designs and symbols to your layers.

MATERIALS LIST

- Manila folders
- Tagboard
- Glue stick
- Scissors
- Pencil
- Large peeled crayons

A crayon rubbing was made from manila folder circles and then painted over with acrylic paint.

Another crayon rubbing was made from purchased stencil letters glued to a piece of tagboard and then painted.

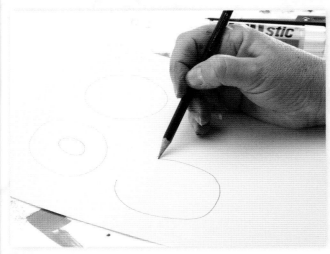

1 Using a pencil, draw shapes on a manila folder.

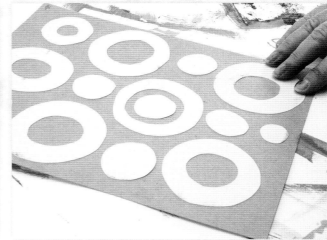

2 Cut out shapes with scissors. Use a glue stick to adhere the shapes to a tagboard background piece. Let dry.

3 Overlay a painted or blank substrate over the tagboard. Use the crayon rubbing technique in the previous section to create texture.

More Plates to Make

You can also create rubbing plates with chipboard letters, letter stickers or stencil letters. Just glue or stick them to a tagboard background.

0123456789

Gluing Tip

Don't use white glue directly from the bottle to adhere shapes to the background piece. When the glue dries, you will see the glue lines as you make your crayon rubbings. For these projects, I only use UHU glue sticks.

STAMPING

Rubber stamping is a form of printmaking most of us are familiar with. I use large chunky foam stamps for adding designs to the layers of my canvases and papers. These stamps can be purchased at most art and craft stores. I find I get better results when I apply the paint to the surface of the stamp with a sponge rather than dipping the foam stamp into a pile of paint on a palette. By applying the paint to the surface of the stamp, you will get a crisper image and keep globs of paint from building up in the negative space of the stamps.

MATERIALS LIST

- Paper, canvas or fabric substrate
- Acrylic paints
- White cosmetic sponges
- Foam stamps
- Large white paper plate

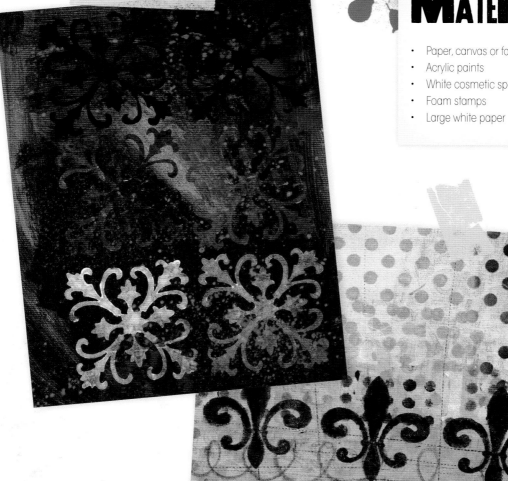

Painted canvases with stenciled polka dots, crayon lines and foam stamped designs.

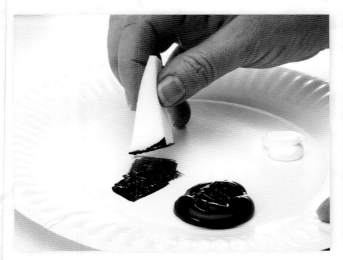

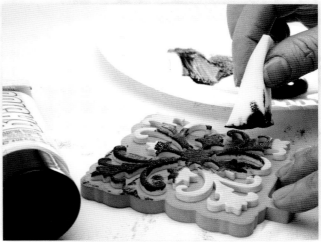

1 Pour a small amount of paint onto a paint palette. Using a cosmetic sponge, dab the bottom of the sponge into the paint, and tap off excess into the palette.

2 With a tapping motion, dab the paint onto the surface of the stamp.

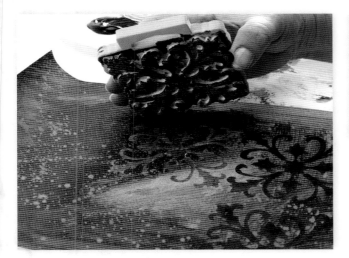

3 Press the stamp onto the substrate and repeat as desired. As you stamp across the substrate, you can variegate the color of paint by adding a small amount of black or white paint to the sponge.

Use Your Color Wheel Sheets

Print stamped images on some of your painted color wheel sheets. I like this technique because it is simple and bold.

Cleaning Stamps

Make sure to clean stamps, as acrylic paint will dry on the stamps and ruin them. Keep a container of water next to your work station and drop the stamps in the water until you have time to wash them with soap under running water.

STAMPING LARGER AREAS

For printing larger areas at one time, purchase a foam stamp set and keep it whole rather than taking the stamps apart. Glue along the perforated lines to keep the stamps together. Then use a foam roller to apply the paint; the roller allows you to cover the area quickly before the paint dries on the surface of the stamp.

MATERIALS LIST

- Paper, canvas or fabric substrate
- Acrylic paint
- Large foam stamp set
- Foam roller
- Large white paper plate

Painted canvases created with a large foam stamp repeated in different directions.

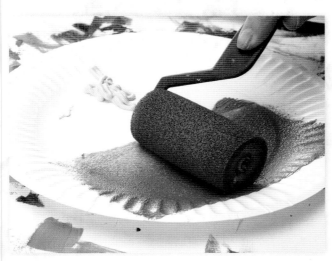

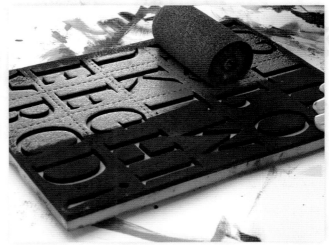

1 Load a foam roller with paint. Roll the roller back and forth through the paint until all the foam is covered in paint. Roll excess blobs of paint off onto another clean plate or a sheet of scrap paper.

2 Roll over the surface of the stamp with the foam roller. Apply paint quickly to keep it from drying before you have a chance to stamp it.

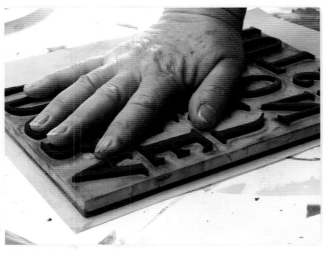

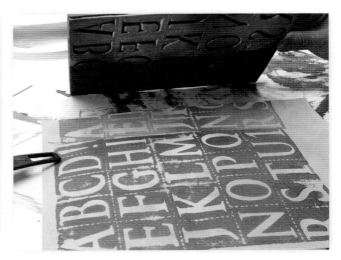

3 Place the stamp on top of the substrate and press down onto the surface.

4 This creates a large-sized stamp.

Pressing Tip

Use a sheet of Plexiglas or a plastic tray on top of the stamp to apply even pressure to the surface of the stamp.

CREATING FOAM STAMPS

Creating your own foam stamps will give you the opportunity to create unique designs any time you choose. Foam is easy to cut and inexpensive. Cut the foam to any shape or size, and you can use the leftover pieces to make other stamps. You can also buy precut shapes out of craft foam that has a sticky back that can be made into stamps.

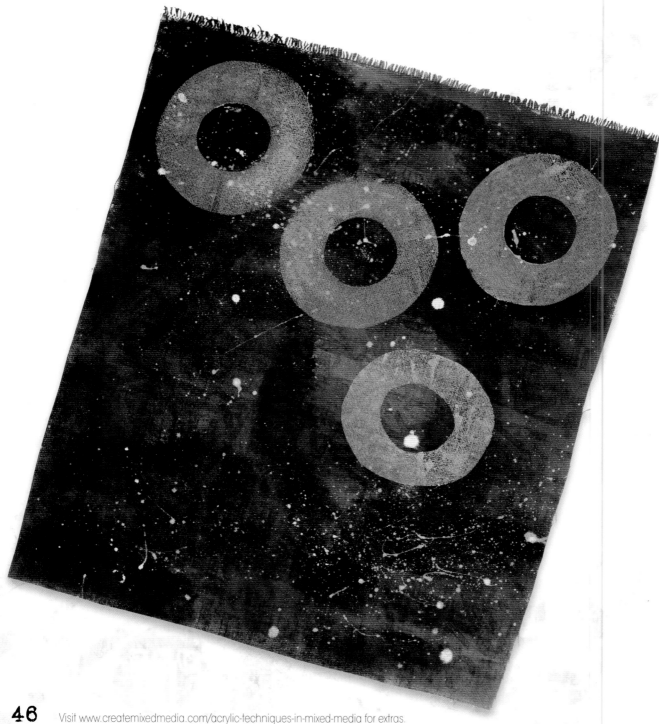

MATERIALS LIST

- Paper, canvas or fabric substrate
- Cardboard
- Craft foam (Fun Foam)
- Acrylic paints
- Craft glue
- Pencil or pen
- Scissors
- Craft knife
- Cosmetic sponge
- Baby wipes

1 Cut one piece of cardboard and two pieces of craft foam to 4" (10cm) square.

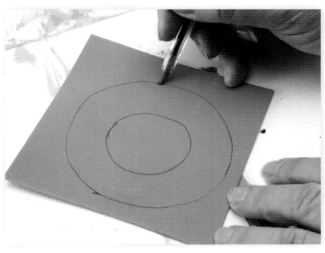

2 Draw a shape on the craft foam with a pencil or a pen.

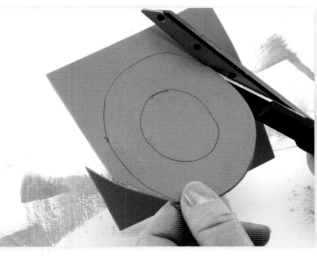

3 Cut out the shape with scissors; for small detailed shapes use a craft knife.

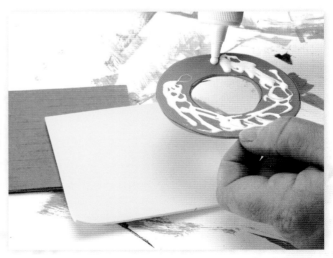

4 Use craft glue to adhere the shape to the other piece of craft foam.

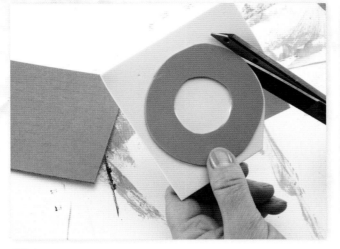

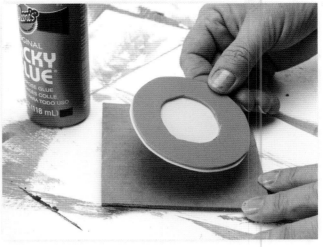

5 Trim away the excess foam from the outside of the shape. This double layer of foam will raise the design from the cardboard surface and keep the paint from building up along the edges of the stamp, making your images crisper.

6 Use craft glue to adhere the foam shape to the piece of cardboard.

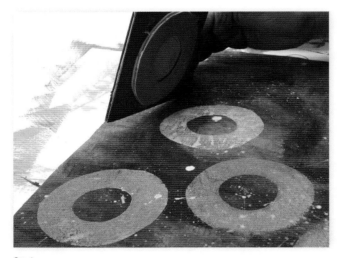

7 When the glue is dry, apply paint with a cosmetic sponge to the foam and stamp on a substrate. Wipe the foam clean with a baby wipe after use.

All Shapes and Sizes

These are several examples of my handmade stamps. These stamps are quick and easy to make.

Cleaning Handmade Stamps

Never wash handmade stamps under running water. Just wipe them off with paper towels or baby wipes to clean.

This is a black-and-white cotton print with layers of stenciled designs, ovals made from handmade stamps and lines made with a correction pen.

A painted paper stamped with foam face stamps and puffy paint lines.

FOUND OBJECT PRINTING

Stamps are not the only thing you can print with. You can make a print from almost any kind of object. Look around your house and see what kind of things you can find. Look for objects that have a fairly flat surface on one side. Look at kitchen gadgets, small toys and in the recycling bin. Secondhand stores are a great and inexpensive source for finding cool stuff to print with, too.

MATERIALS LIST

- Paper, canvas or fabric substrate
- Acrylic paints
- Cosmetic sponges
- Paintbrush
- Items for printing
- Large white paper plate

A painted sheet of paper stamped with circle designs made from empty tape rolls and lines made with a tracing wheel (demonstrated in "It's Elementary").

A print sampler created with white paint on black painted canvas using found objects.

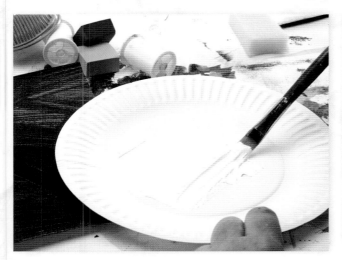

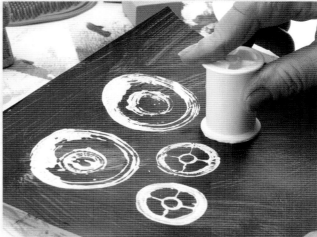

1 Pour paint onto the plate and spread the paint with a paintbrush. Dip the tool or object into the paint to coat the bottom of the object. For a crisper image, dab a cosmetic sponge into the paint and tap paint on the part of the object you want to print.

2 Press the object onto the surface of the substrate. In this case, I'm using an empty spool of thread. Re-apply paint and repeat as desired. Clean the object after use with warm soapy water.

More Objects to Find

Experiment with all types of objects as I've done here with a kitchen whisk, a tire from a child's toy and a long Lego block. You could also consider other kitchen tools and gadgets, small toys, empty tape rolls, sponges, corks, erasers, plastic packaging, cardboard scraps and plastic and metal lids.

STENCILING AND PAINTING TECHNIQUES

I love to experiment with different techniques for applying paint to paper and textiles, and there are probably endless possibilities. I will experiment with just about any idea or tool I can get my hands on. I have a few favorite painting techniques that I have developed over time, but the two that I use the most are stenciling and combing. These techniques can be used in your artwork to create a variety of patterns and designs.

Visit www.createmixedmedia.com/acrylic-techniques-in-mixed-media for extras.

53

STENCILING TECHNIQUES

Stenciling is probably my favorite technique and is something that I do in much of my work. Stenciling is a method of applying a design by brushing, sponging or spraying paint through a cutout, or a negative space, that is placed on a substrate. Images can be repeated and larger areas can be covered quickly as compared to stamping or other printmaking techniques. Stencils can be purchased, found and made and this section of the book will teach you about all three.

Unattractive floral print that I use as a tester piece for stenciling techniques and paint combinations. Eventually I will use all these pieces in one of my projects.

Heavyweight upholstery floral print with stenciling. I love the original pink flower design showing through the layers.

Stenciling With a Brush

Stenciling with a stencil brush is one of the first ways I learned to stencil. Stencil brushes have bristles that are flat on the bottom and can be used to stencil very crisp images by using very little paint. Stencil brushes work well on stencils that are a bit deeper, as the bristles can get down to the surface of the substrate.

MATERIALS LIST

- Paper, canvas or fabric substrate
- Acrylic paint
- Stencil brush
- Stencil
- Painter's tape
- Large white paper plate

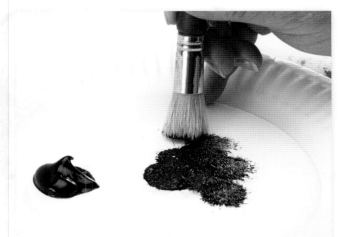

1 Lay a stencil on top of a substrate. If you like, tape the stencil into place with two or three small pieces of tape. Pour paint onto a palette.

Dab the stencil brush into the paint and tap off the excess paint onto the palette several times. Your brush should not have excess globs of paint on it.

Stenciling Tip

The key to getting crisp stenciled images is to have a fairly dry brush and to keep the brush at a vertical angle, or upright position. This keeps the paint from seeping under the stencil.

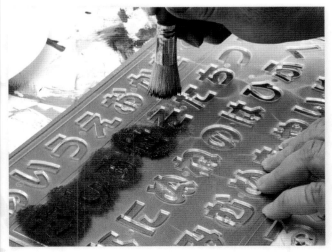

2 In an up-and-down motion, tap the brush into the negative space of the stencil. Your brush should be perpendicular to the work surface. Reload your paintbrush as needed to fill in the stencil.

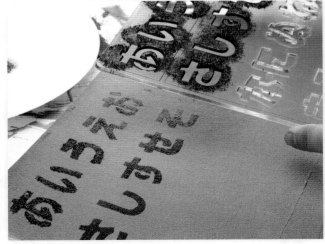

3 Carefully peel off the stencil and repeat as desired. Wash the stencil brush after use with soap and water.

Stenciling With Sponges

White cosmetic sponges are great for stenciling; they have a flat bottom and can be washed and used again. I tend to use sponges on small or thin stencils or when I need to control the paint along the edges of a piece. I also like to use them when I am stenciling on the inside of a journal. They are not good for covering large surfaces quickly. You can purchase these sponges from the cosmetic department of any drugstore.

MATERIALS LIST

- Paper, canvas or fabric substrate
- Acrylic paints
- Cosmetic sponge
- Stencil
- Painter's tape
- Large white paper plate

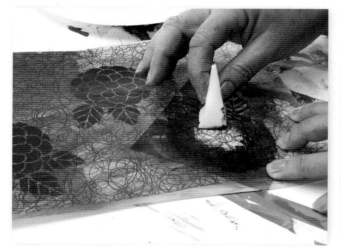

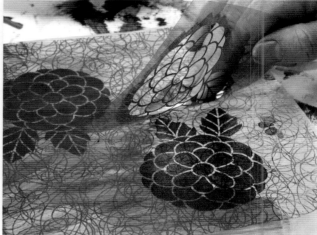

1 Lay a stencil on top of a substrate. Tape the stencil down with two or three small pieces of tape. Pour paint onto a palette. Dab the cosmetic sponge into the paint and tap off the excess paint onto the palette. In an up-and-down motion, tap the sponge into the negative space of the stencil.

2 Carefully peel off the stencil and repeat as desired.

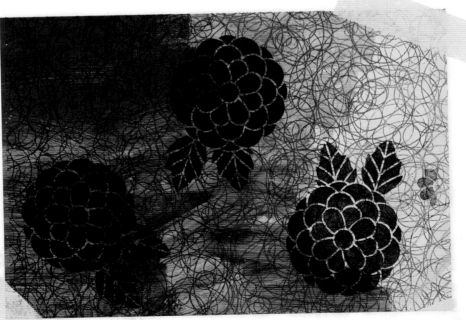

Stenciling With Foam Rollers

I use foam rollers when I am working with larger stencils. Foam rollers can cover large areas quickly and easily, and I can variegate or add color as I am stenciling. When you're done, wash the rollers out with soap and water so paint doesn't dry on the roller.

MATERIALS LIST

- Paper, canvas or fabric substrate
- Acrylic paint
- Foam roller
- Stencil
- Painter's tape
- Large white paper plate

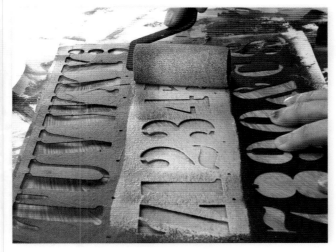

1 Lay a stencil on top of a substrate. Tape the stencil in place with two or three small pieces of tape. Pour paint onto a palette. Roll a foam roller through the paint on the palette until the entire roller part is covered with paint. Roll back and forth on a palette to remove excess paint. Roll over the top of the stencil; re-apply paint as necessary.

2 Carefully remove the stencil from the substrate.

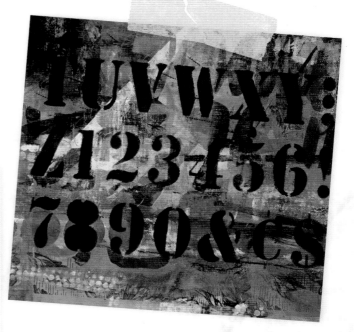

Getting a Variegated Look

To get a variegated or blended look, try adding white or an analogous color to the roller. Begin with one color of paint and roll some of the paint on the stencil. Then add more paint to the palette and continue stenciling to blend and create new hues. Remember, if you use colors that are across from each other on the color wheel, you will get mud!

Sign up for the free newsletter at www.createmixedmedia.com.

57

MAKING STENCILS FROM FOUND OBJECTS

You can purchase stencils, but you can also find found materials that can be used as stencils. I love to search everywhere I go for things that I can use as stencils. Thrift, hardware, office supply and grocery stores are loaded with fun materials that can be used as stencils—just look for anything that has a negative space. Sometimes you may have to cut the object up to be able to use it as a stencil.

MATERIALS LIST

- Paper, canvas or fabric substrate
- Acrylic paint
- Found stencil
- Painter's tape
- Scissors
- Brayer
- Large white paper plate
- Rollers, brushes or sponges

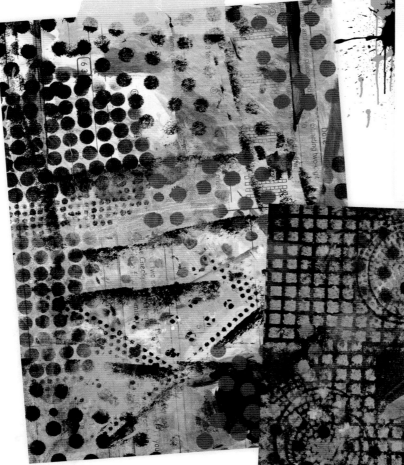

This piece of paper was painted first with a paintbrush, then all the designs were applied with found stencils: a needlepoint canvas, a piece of a plastic container and a stencil made from a coffee cup holder.

I used a sheet of paper from a math book with random painting from a paintbrush. Then I stenciled using the coffee cup holder stencil.

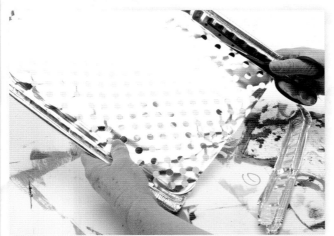

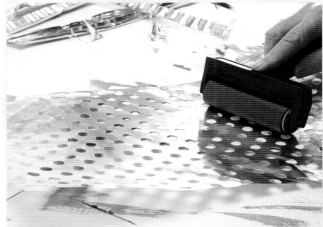

1 Often with found stencils, you'll need to do some cutting or combining to make the stencil work its best. If necessary, trim excess edges away to create a surface that can lay flat.

2 Use a brayer to help the stencil lay as flat as possible.

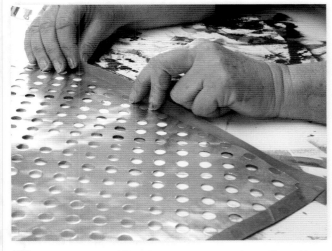

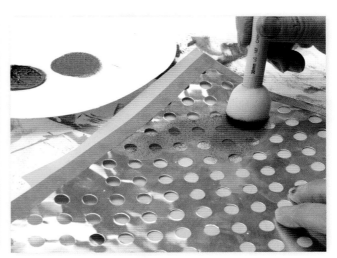

3 If the edges of the stencil are sharp, cover the edges with masking tape or painter's tape.

4 Use rollers, brushes or sponges to stencil.

What Could Be a Stencil?

Potential stencils are everywhere! Plastic mats, containers, metal trays and packing materials can all be cut up and used as stencils. Try doilies, rug hooking mesh, drawing templates, sequin waste (the plastic ribbon that is left after sequins are punched out), plastic baskets, sink drains, leftover chipboard or die-cut scrapbooking papers, too.

Using Paper and Fabric Stencils

Use a paper stencil once, then let the paint dry before using it again. The dried paint will make the stencil sturdier and last longer.

Cloth doilies make great stencils, too. Just paint the doily, on both the front and back, before using. Again, the paint will make the doily sturdier for stenciling.

CUTTING MANILA FOLDER STENCILS

Manila folders are a great material for making stencils. They are durable, inexpensive, and you can find them around your house. Any time I want to make a quick stencil, I can grab a folder and cut several stencils from a single folder. You should never wash a manila folder stencil, but the more layers of paint they get, the longer they last.

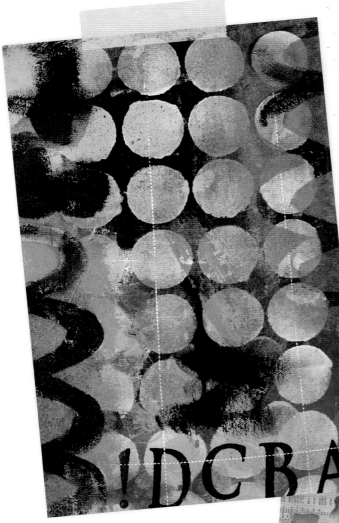

MATERIALS LIST

- Paper, canvas or fabric substrate
- Manila folder
- Acrylic paint
- Pencil
- Foam roller or stencil brush
- Scissors
- Large white paper plate

A heavyweight canvas randomly painted different colors with stenciled circle shapes and manila folder stenciling along the edge.

A phone book page painted yellow, stenciled with blue paint, using a manila folder stencil.

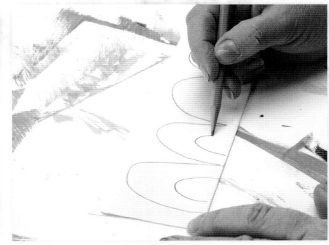

1 With a pair of scissors, cut a manila folder into four sections. Fold one of the sections in half lengthwise.

2 Draw a design on the folded edge side with a pencil.

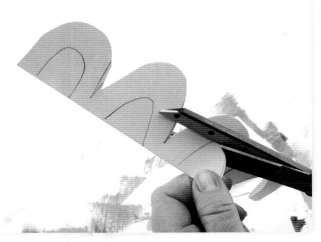

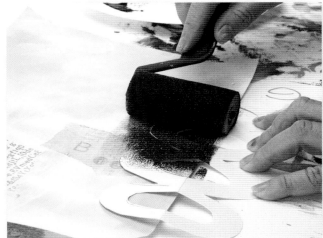

3 With a pair of scissors, cut out the design, being careful not to cut along the fold.

4 Open the stencil. Place the stencil on the substrate and use a stencil brush, for smaller designs, or a roller, for larger ones, to apply paint. This stencil looks great along the edge of a piece.

Save the Leftovers

Save the pieces left over from cutting out your shapes to create rubbing plates (see the Creating Collagraphs or Rubbing Plates technique in this chapter).

COMBINING MANILA FOLDER STENCILS

You can combine several manila folder stencils to create larger ones. Because these do tend to be larger stencils, I use a foam roller to apply paint.

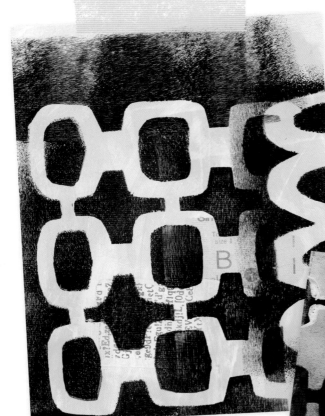

MATERIALS LIST

- Paper, canvas or fabric substrate
- Manila folder
- Acrylic paint
- Pencil
- Craft glue or tape
- Scissors
- Large white paper plate
- Foam roller

A piece of drawing paper collaged with torn pieces of copy paper and sewing patterns, painted with a light wash of blue paint and stenciled with a manila folder stencil.

Black-and-white floral fabric randomly painted, with stenciled circles and a manila folder stencil as the final layer.

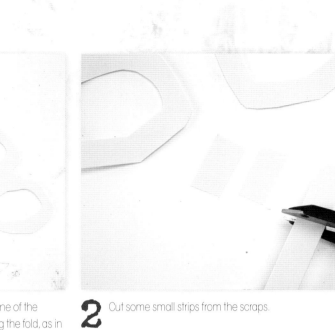

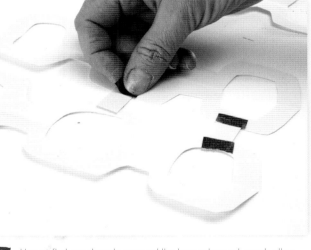

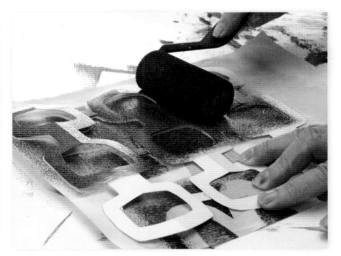

1 Again, cut the manila folder into four sections. Fold one of the sections in half lengthwise and create a stencil along the fold, as in the previous lesson. Trace the design on the other three sections and cut it out with scissors.

2 Cut some small strips from the scraps.

3 Use craft glue or tape to connect the larger shapes to each other using the small scrap pieces.

4 Use a foam roller to stencil. Let the stencil dry after use.

Try It With Spray Paint

These stencils also work well with spray paint. I always spray paint outside and use protective gear: a mask, gloves and safety glasses.

CREATING MULTIPLE STENCIL EFFECTS

You can create a variety of effects using just one stencil and a few colors of paint. Variegating the paint will give you a different look (see the Stenciling With Foam Rollers technique in this chapter) as will using the stencil as a stamp, covering it with paint and making a print from it. Play around to see what you can create!

MATERIALS LIST

- Paper, canvas or fabric substrate
- Manila folder
- Acrylic paints
- Pencil
- Foam roller or stencil brush
- Brayer
- Craft knife and cutting mat
- Large white paper plate

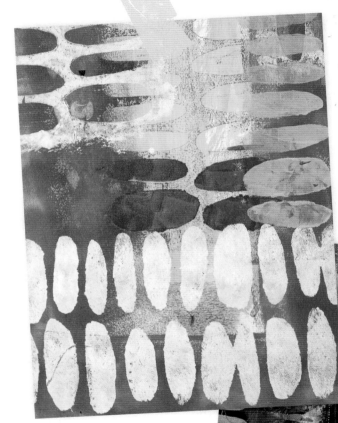

Drawing paper with one stencil that I stenciled and reverse printed until the sheet was covered.

This black cotton duck fabric was stenciled with green and magenta paint. I then added paint pen marks and tracing wheel paint lines.

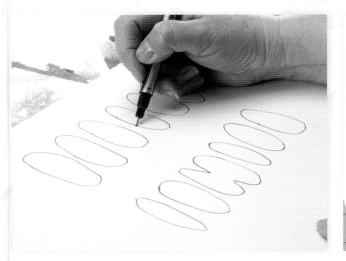

1 Draw a design or shapes in the center of a manila folder.

2 Use a craft knife on a cutting mat to cut out the shapes.

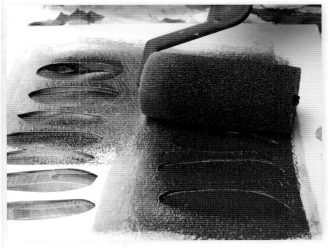

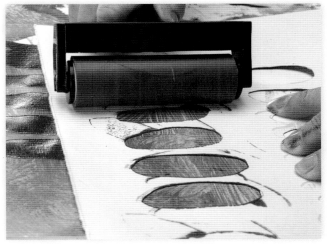

3 On a substrate, use a foam roller or a stencil brush and begin stenciling.

4 Move the stencil around and add white or an analogous color to your original color as you are stenciling (see Getting a Variegated Look in the Stenciling With Foam Rollers technique).

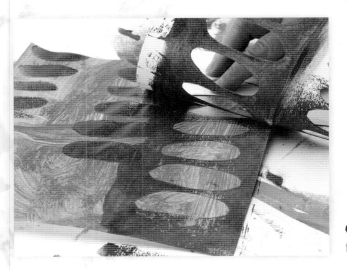

5 When the front of the stencil is still wet, flip it over and print the front by rolling over the stencil with a brayer. Peel off the stencil. Let both the front and back of the stencil dry before using it again.

CUTTING PLASTIC STENCILS

Clear transparencies are a great material for making stencils. The plastic will last a long time, longer than stencils made of paper or manila folders, and can be used over and over. Lay the transparency over a design, magazine page or a photograph and trace with a black permanent marker. Then cut out the design to make a stencil.

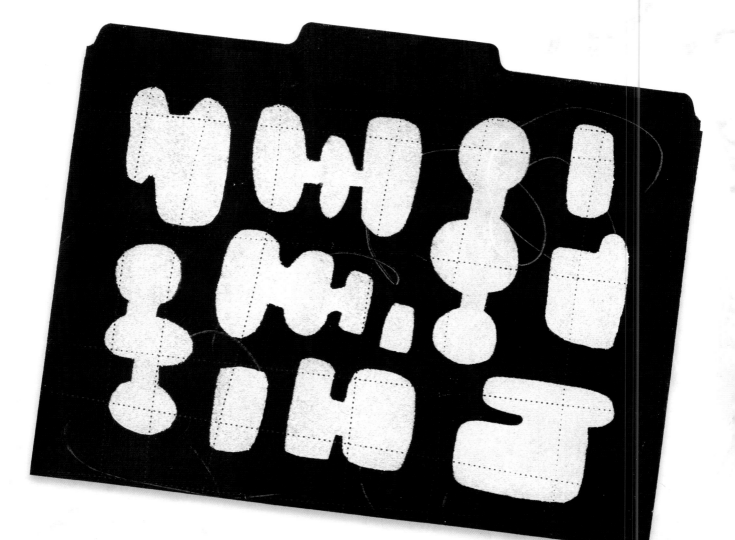

MATERIALS LIST

- Paper, canvas or fabric substrate
- Paper for drawing design
- Transparencies or overhead projector sheets
- Acrylic paint
- Foam roller or stencil brush
- Pencil
- Permanent marker
- Craft knife and cutting mat
- Large white paper plate
- Painter's tape

1 Draw abstract shapes on a piece of paper with a pencil. Lay a clear sheet of plastic over the pencil drawing and tape to hold it in place. Trace over the shapes with a black permanent marker.

2 Remove the plastic from the paper and cut out the shapes with a craft knife on a cutting mat.

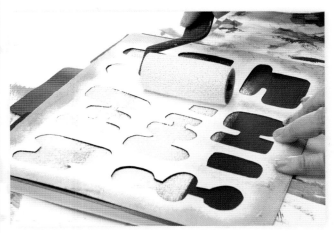

3 Stencil on a substrate with a foam roller or a stencil brush. I stenciled on a manila folder painted black for this project. You can clean the stencil with soap and water.

Cutting Tip

When you cut out the stencil, don't move the knife as much as you move the paper or transparency. Keep the tip of the knife on the paper while cutting, moving the paper around with your other hand. This makes it easier to cut out circular shapes.

LAYERING STENCILS

It's fun to experiment with stencils, and you can get some wonderful results by layering them. Let each painted layer dry before you add the next stencil. I suggest starting with a stencil with a large negative space for the first stencil and then using a stencil with a smaller overall pattern or smaller negative space for the second stencil.

MATERIALS LIST

- Paper, canvas or fabric substrate
- Acrylic paints
- Two or more stencils
- Painter's tape
- Cosmetic sponge
- Stencil brush
- Large white paper plate

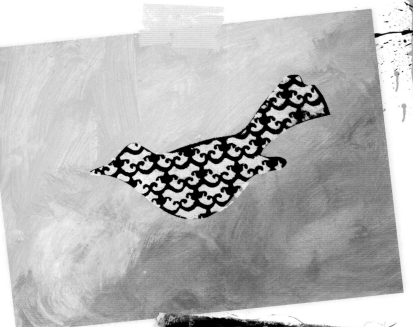

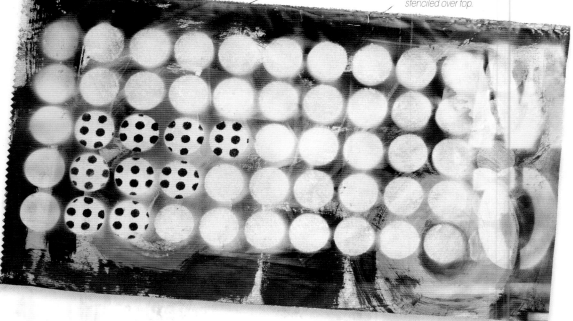

Painted fabric with large white circles stenciled first and smaller black circles stenciled over top.

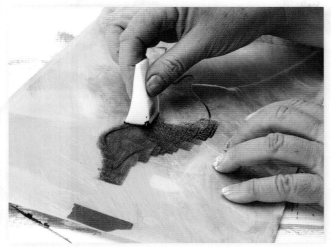

1 Start with a stencil that has a large negative space. For this project I used a bird stencil. Tape the stencil on top of a substrate. Stencil with one color of paint; let dry. I used black paint on a white cosmetic sponge. Do not remove the stencil.

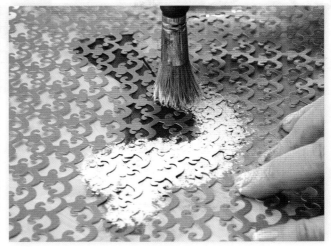

2 Choose a stencil with small negative space. Place it on top of the other stencil and tape it in place. Stencil with a different color of paint. Here I used white paint with a stencil brush.

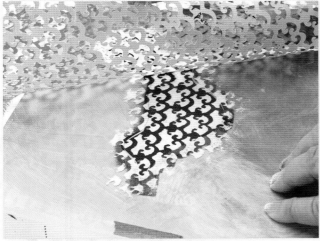

3 Carefully peel off the top stencil.

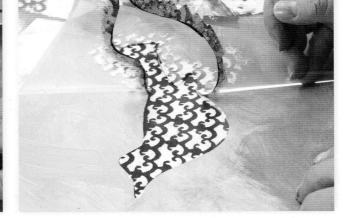

4 Carefully remove the bottom stencil to reveal the design.

Make More Layers

You can stencil as many layers as you like; just leave the original stencil in place, and let the paint dry between each layer.

MAKING TWO-PART STENCILS

Two-part stencils use two stencils together to create one image. Often the first stencil is a basic shape, and the second stencil adds the smaller details. You can draw the stencil as a whole first, then trace the shape onto one piece of plastic and the details onto a second piece that will be layered on top.

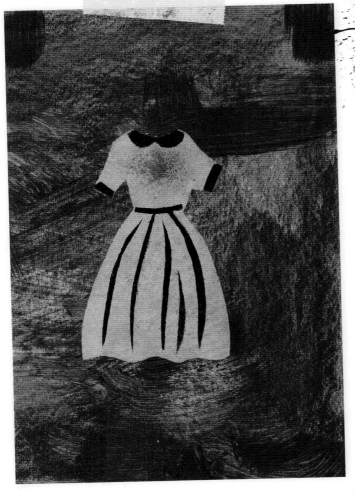

MATERIALS LIST

- Paper, canvas or fabric substrate
- Paper for drawing design
- Two transparencies or overhead projector sheets
- Acrylic paints
- Pencil
- Fine-point permanent marker
- Painter's tape
- Stencil brush or sponge
- Large white paper plate
- Craft knife and cutting mat

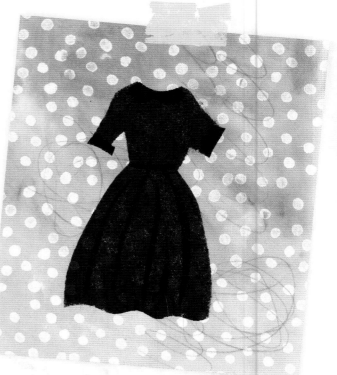

White polka-dot fabric with scribbled pencil lines and painted with a wash of blue; the dress shape was stenciled first, then the dress detail.

Visit www.createmixedmedia.com/acrylic-techniques-in-mixed-media for extras.

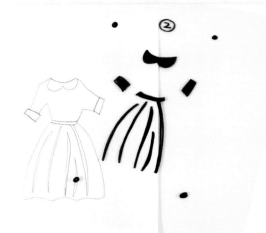

1 Draw a simple design on a sheet of paper. In this case, I drew a dress with some details. Lay a sheet of plastic over the drawing and tape it in place. Draw over the outline of the dress with a black permanent marker.

Make four dots in each corner. These will be your quick-and-easy registration marks for lining up the second stencil.

Lay a second sheet of plastic on top of the dress drawing and tape it in place.

Make dots in each corner to match the dots on the first stencil. Draw the details of the dress with a black permanent marker.

2 Remove the transparencies and cut each one on the drawn lines with a craft knife and a cutting mat.

Tape the first stencil to the substrate and use a sponge or brush to apply paint. Let the first stencil dry and leave it in place.

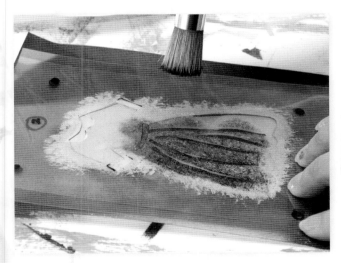

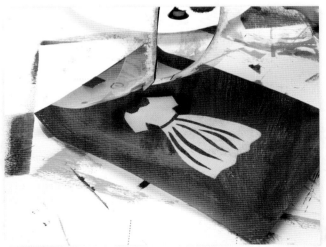

3 Place the second stencil on top of the first, match the registration marks and tape it in place. Use another color of paint and stencil with a brush or sponge.

4 Carefully remove both stencils to reveal the image.

PAINT COMBING TECHNIQUE

With this technique you can create several sheets of beautiful and unique paper in a very short period of time. It's fun to scribble on a piece of paper with a variety of colors and then lay down a rich layer of paint on top. The colors are revealed as you scrape away the paint with a comb. Adding glazing liquid will slow down the drying time of the acrylic paint so you can paint over the crayons and still have time to scrape away the paint while it is still wet. Use a variety of comb sizes to create different effects and textures. The combing technique is inspired from a paste-paper technique that many bookmakers use for cover and end papers for their handmade books. Paste-paper is the process of painting a colored paste on the surface of a piece of paper, and then making patterns in the wet paste with combs or other tools. What I discovered was that this paste-paper technique works well with acrylic paint and just about any substrate, paper, magazine pages, photos and textiles as long as the surface is relatively flat.

MATERIALS LIST

- Heavy drawing paper
- Acrylic paint
- Acrylic glazing liquid
- Crayons
- Paintbrush
- Comb
- Large white paper plate

This heavyweight drawing paper with crayon scribble lines was painted over with blue paint and scraped with a comb while the paint was still wet.

This piece is paper painted and scraped with a comb while the paint was still wet, then stenciled after the paint was dry.

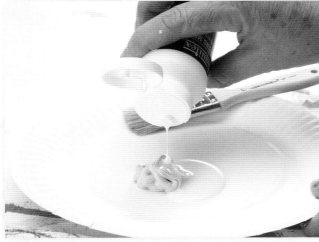

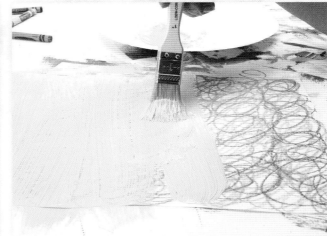

1 With several colors of crayons, scribble all over a piece of drawing paper. Place a puddle of paint on your palette. To slow down the drying time of the paint, add a small amount of acrylic glazing liquid to the paint.

2 With a large paintbrush, quickly paint over the surface of the crayon scribbles.

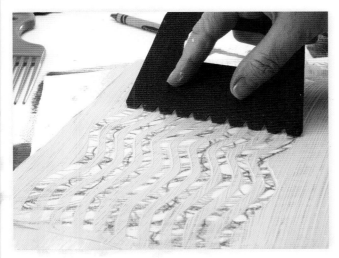

3 Quickly scrape across the surface of the paper with a painting comb, removing the paint to reveal the crayon design.

Comb Ideas

You can use found combs, including plastic forks, hair picks and hair combs, to create combed paper. Or create your own combs with a small piece of cardboard. Cut small slits in one end and then trim away every other section, as shown below, second from right.

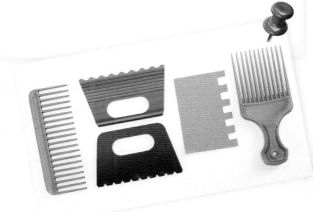

LAYER IT LUSH

Now that you have learned different techniques, it is time to start combining them to create lush, layered surfaces. You could start with a scribble, add some stenciling and then end with stamping or mark making. Alternate any of the techniques in this book to create your own unique pieces of textiles, canvas and papers. When I create, I do not have a method to my mixed-media madness; to me it really is controlled chaos. What I say is, "start with a broom and end with a needle," meaning I start very large and loose, build up the layers and end with the smaller details. On each piece, I like to leave at least a small portion of each layer visible. But during the process, I let the materials direct me; I leave myself open to the mystery of the creative process. You'll be amazed by what is hidden and what is revealed.

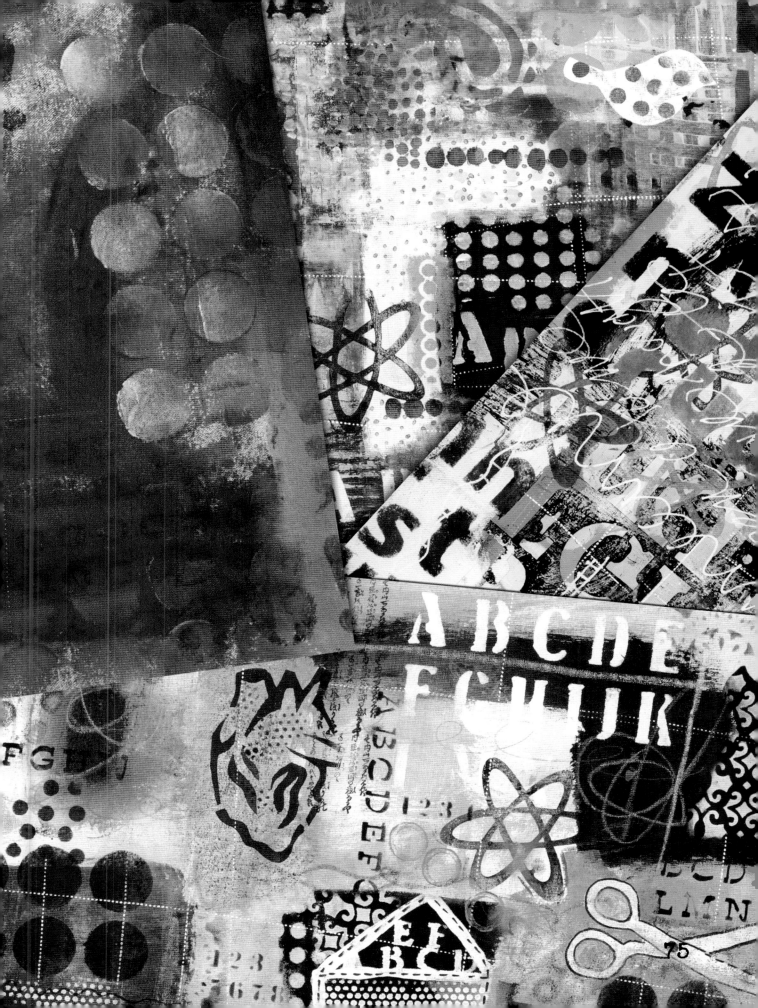

THE ART OF LAYERING 101

The layering process can be done in any sequence and can be done on different substrates. Beginning with a magazine page is a good way to start. You won't have a blank page to begin with and you can pull some of the colors from the page to help create your palette.

MATERIALS LIST

- Magazine page
- Collage materials
- Acrylic paints
- Caran d'Ache Neocolor crayons
- Poster paint pens
- Glue stick
- Paintbrushes
- Stencil brush
- Stamps and stencils
- Large white paper plate
- Found objects
- Water container

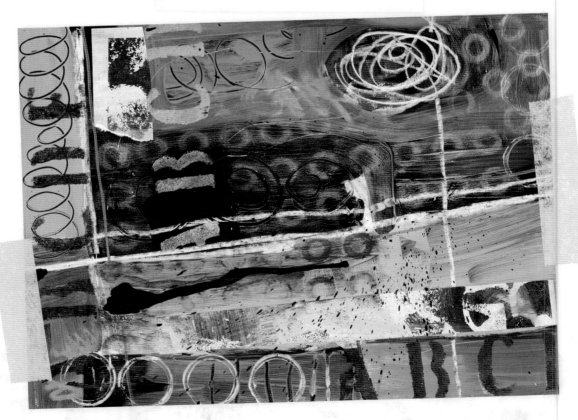

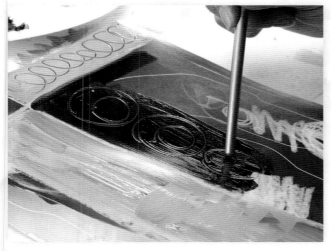

1 Begin the piece as you did on with the Magazine Page as Substrate technique in the "It's Elementary" chapter. While the paint is still wet, use the handle of your paintbrush to scratch lines into the wet paint to reveal the color underneath.

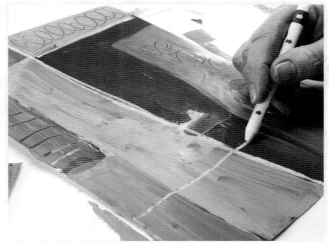

2 When the paint is dry, redraw some of the grid marks with a white crayon, if you wish.

3 Use a glue stick to collage bits of painted paper or other scraps to the surface.

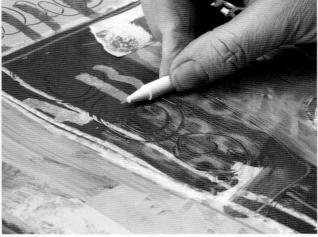

4 Continue to add layers with lines using poster paint pens. Use a stencil brush and an alphabet stencil to add letters with acrylic paint. Place the stencil underneath the magazine page and use a crayon to make a crayon rubbing of letters in selected areas, as shown here.

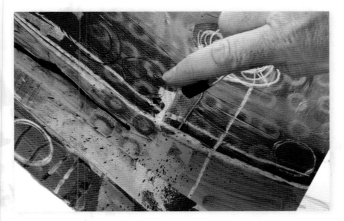

5 Use found objects and acrylic paint to make printed shapes or lines. On the left, I used the tube from a roll of paper towels to make circles.

Thin some paint with water. Make drips of paint by placing a puddle on the surface and lifting the surface to make the paint run. Add spatters by loading the thinned paint on a brush and running your finger over the bristles to make the paint fly onto the surface.

THE ART OF LAYERING 102

Now you are ready to begin on a large blank canvas. My beginning layers tend to be a bit looser. I like to see how many layers I can add and still have the piece make sense. In the end, it is interesting to see what I have chosen to conceal or reveal.

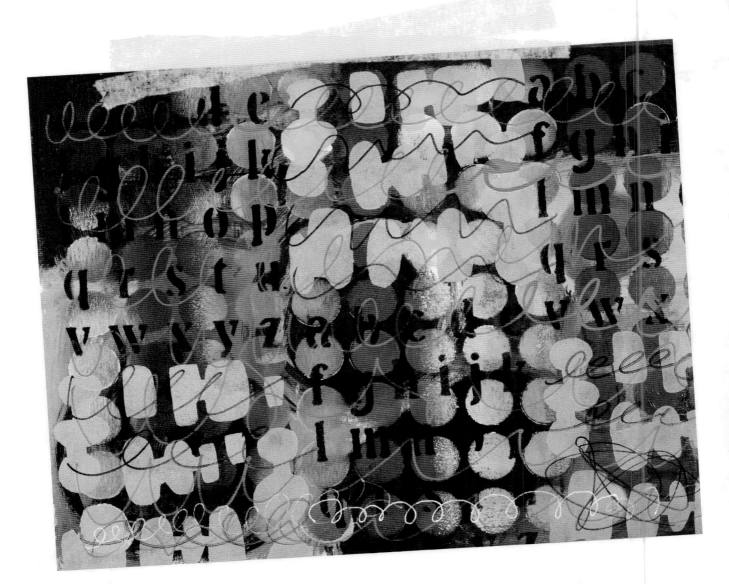

MATERIALS LIST

- Paper, canvas or fabric substrate
- Collagraph plates
- Collage paper including sewing pattern pieces
- Acrylic paints
- Matte medium
- Drawing materials, such as pencils, permanent markers, poster paint pens or correction pens
- Crayons
- Stencils
- Foam roller
- Flat paintbrushes
- Stencil brush
- Large white paper plate

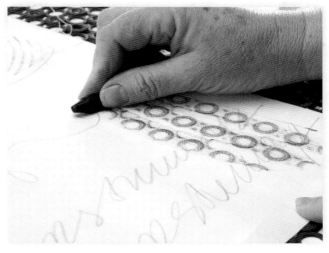

1 Begin the canvas with penciled scribble lines and crayon collagraph rubbings.

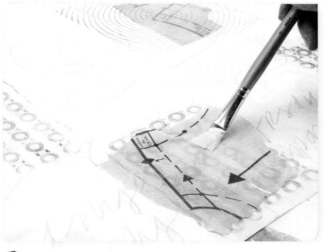

2 Adhere sewing pattern pieces to the canvas with matte medium and a paintbrush.

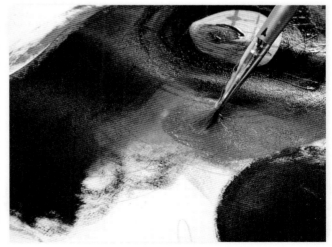

3 Begin freehand painting with a harmonious color palette of paint, plus white. Here I used magenta, Quinacridone Magenta and Cadmium Orange.

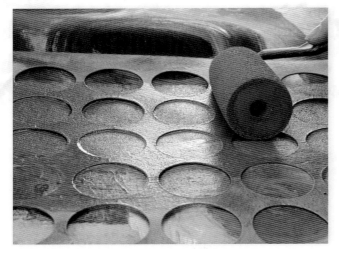

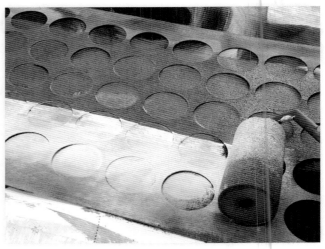

4 Use a large stencil and a foam roller to paint over the top of the painted canvas. I used a large circle stencil.

5 Add some white to your palette and create a tint of the paint color. Add some stenciled circles of this color, too.

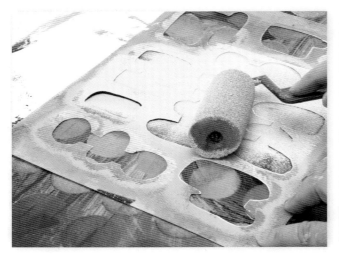

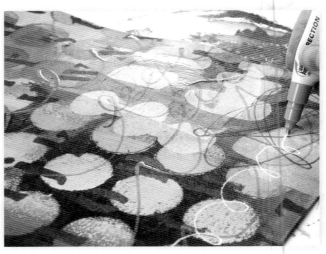

6 Use smaller stencils, a stencil brush and different colors of paint to add more layers of stenciling. I used one of my hand-cut plastic stencils with light blue permanent paint.

7 Add lines with paint pens, permanent markers and a correction pen.

This is a fairly large canvas measuring approximately 3' x 4' (91cm x 122cm). I started randomly painting with lime green and magenta paint on a piece of painters canvas. This piece has many layers; the main element that looks like a flower design is actually a found stencil, which is a plastic sink drain I found at a discount store.

One of my favorite combinations is black and white with a pop of a bold color– in this case, red. Every once in a while, I need a break from all the saturated colors that I use most of the time, and black and white never fails to disappoint me.

Back to Basics

When you get stuck, try making a painting or a collage in just black and white or another limited color palette.

THE PROJECTS

At this point, you may have several sheets of painted papers and textiles of all sorts. I like to have a good stockpile of these materials to work with; this is what I call my "stash." When my stash gets low, I will spend a day or two just making sheets of painted papers and textiles. I am not too concerned with how I might end up using the painted and collaged materials, although, as I am creating the papers and fabric, project ideas are coming to mind. Making your stockpile is a great way to just loosen up if you find yourself stuck on a project or idea.

I love using my own painted materials in my mixed-media projects; these will have a distinctive look, which I know is mine. I usually start all my pieces on a very large piece of paper or textile but I also intend to use every scrap of the leftovers so nothing goes to waste. You can add the tiniest piece of a leftover scrap to almost any mixed-media project. The projects in this chapter are some of my favorite ways to use my "stash," and you can continue to explore how to use your painted and collaged materials for your mixed-media projects.

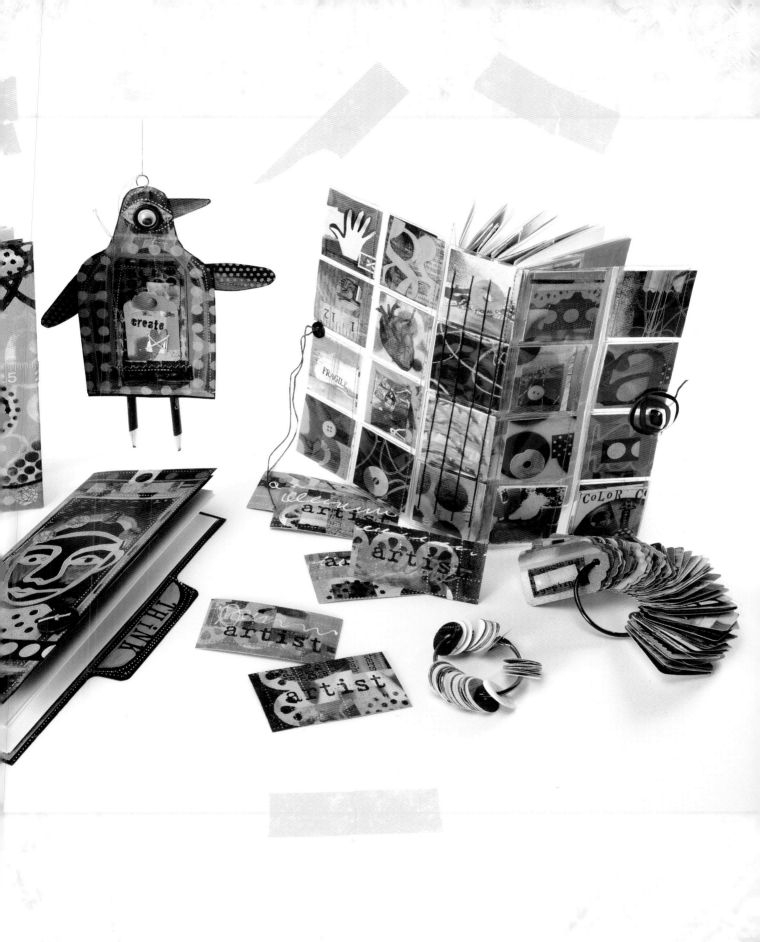

BUSINESS CARDS

I think everyone wants a business card that will stand out and that people will remember. There are plenty of companies that can make beautiful business cards for you, but I prefer to hand someone a tiny piece of my own artwork as my business card. This is a wonderful use for your painted scraps and bits, and you can make lots of cards in a very short period of time.

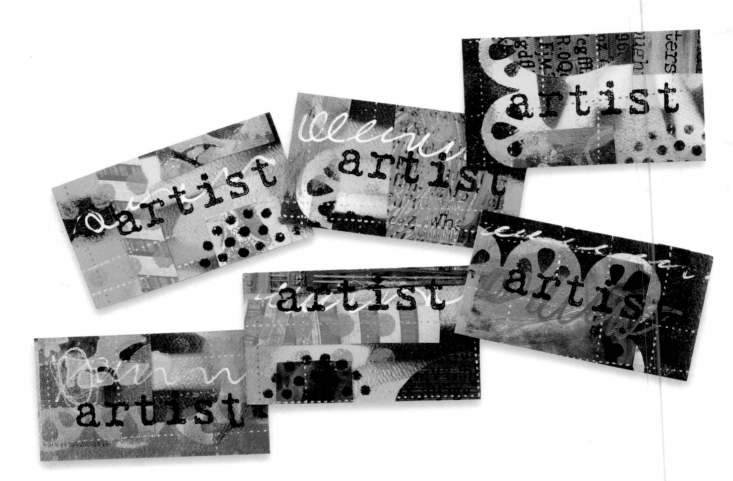

MATERIALS LIST

- Painted watercolor paper
- Painted paper and fabric scraps
- Permanent adhesive address labels
- Glue stick
- Rubber stamps
- Stamp pad
- Acrylic paint
- Computer
- Pencil
- Embellishments
- 1" (25mm) paintbrush
- Paper cutter

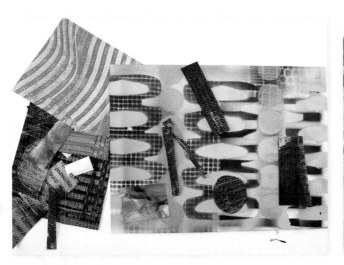

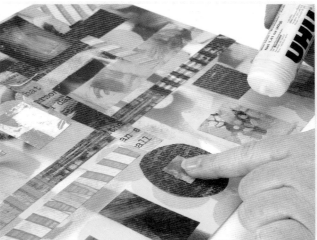

1 Begin with a sheet of painted watercolor paper on which you've used different techniques to apply designs.

2 Using bits and pieces of painted paper and fabric scraps and a glue stick, collage the watercolor paper with random shapes. Add as many layers to the watercolor paper as you like, including colored tape, stickers, brads or bits of photos.

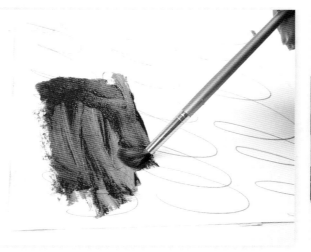

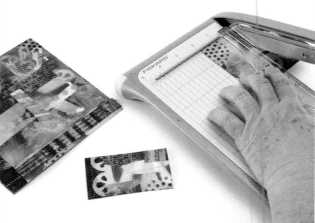

3 Scribble on the back of the piece with a pencil and paint over the lines using acrylic paint and a 1" (25mm) paintbrush. Let dry.

4 Use a paper cutter to cut the watercolor sheet into 2" x 3 ½" (5cm x 9cm) pieces. This is standard business card size.

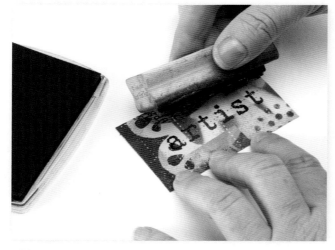

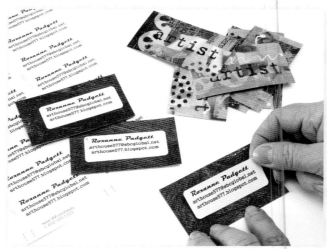

5 Rubber stamp and/or draw on the fronts of the cards.

6 Create labels on a computer and print on permanent address labels. You can add your name, phone number, website or blog. Place the labels on the backs of the cards.

Make a Business Card Bag

Make a small painted zippered canvas bag to hold your business cards. Just make a smaller version of the zippered bag project (near the end of this chapter), cutting the zipper down to your desired size.

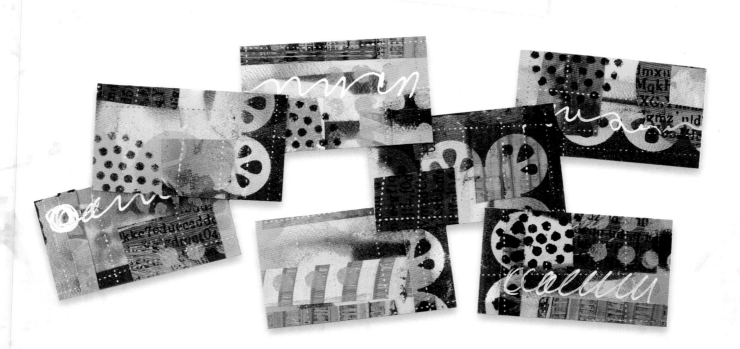

Sign up for the free newsletter at www.createmixedmedia.com.

87

SCRAP TAGS

You can make tags from your painted papers or your used plate palettes and embellish them with bits of other projects. I use all my scraps, even down to the "bits." Nothing goes wasted or unused. As my scraps get smaller and smaller, I tend to organize them with other like-sized pieces in containers or plastic zippered bags. Sometimes the tiniest unique scrap can make all the difference in a mixed-media piece.

These tags are fun and easy to make, and you can use them for a variety of projects. Try using them as gift tags, making a book out of the tags or gluing along the edge of a journal page.

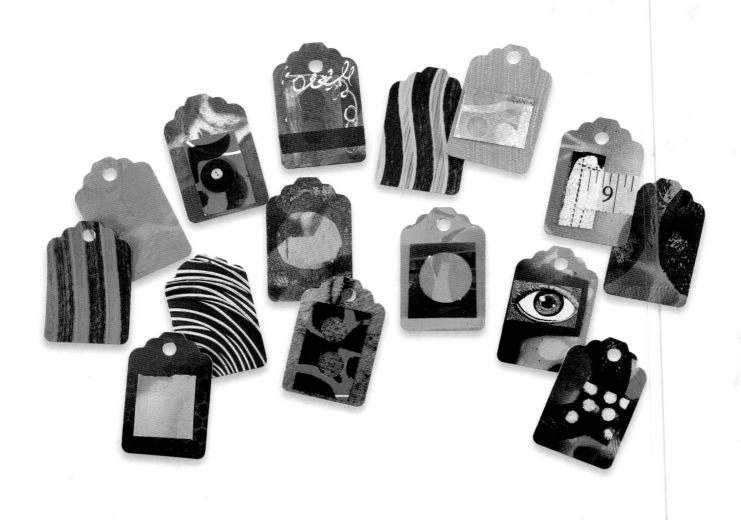

Visit www.createmixedmedia.com/acrylic-techniques-in-mixed-media for extras.

MATERIALS LIST

- Painted paper and canvas scraps
- Colored binder ring
- Colored tapes
- Brads
- Ribbon and/or cording
- Permanent markers
- Glue stick
- Hole punch
- Small awl
- Tracing wheel
- Tag-shaped punch
- Shape punches

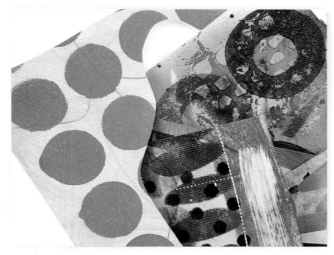

1 Collect some large pieces of painted paper scraps. For these tags, I chose pieces of heavier-weight paper and watercolor paper.

2 Use a tag-shaped punch to punch out several tags. Turn the punch over to see what part of the paper you'll get on each tag.

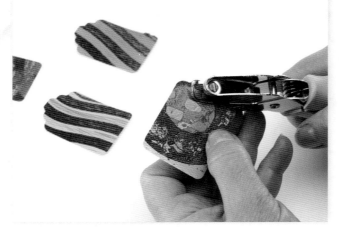

3 Use a hole punch to punch a hole at the top of the tags.

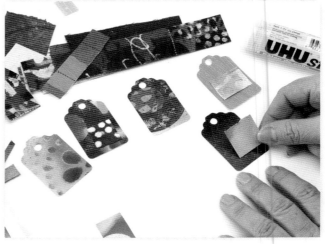

4 Start collaging the tags with a glue stick and the scraps of painted paper and canvas from the "bits."

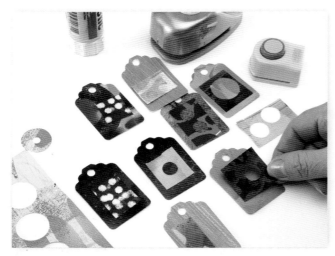

5 Use shape punches to punch out shapes from the small scraps, like circles and stars, to collage on the tags. Then use the leftover or negative pieces in your collages, too.

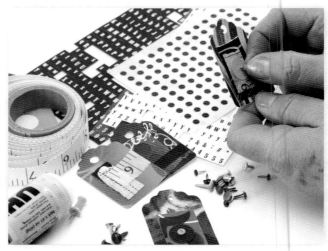

6 Punch holes with a small awl or hole punch and add brads.

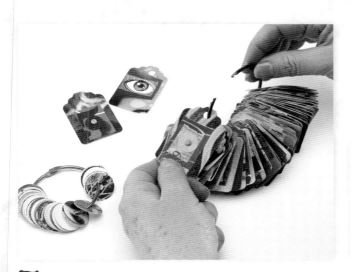

More Ideas to Try

These tags are a perfect opportunity to try all sorts of embellishment ideas. Add colored tapes. Add lines with a tracing wheel or permanent markers. Add a ribbon or string to the top hole. Be creative!

7 Place the tags on a colored binder ring to create a scrap tag book.

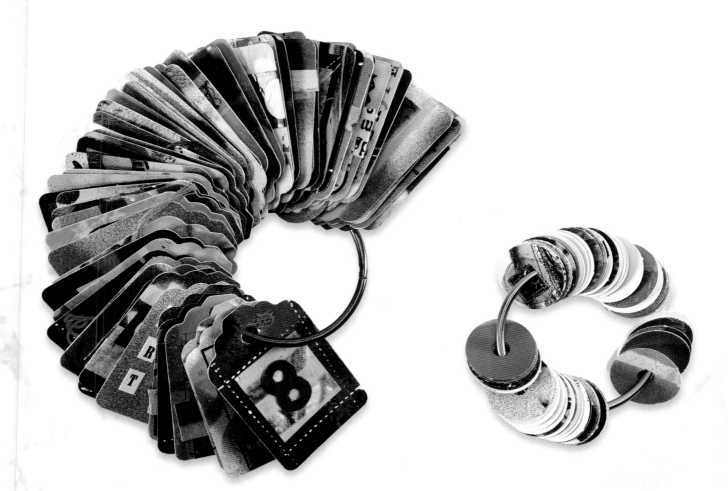

PAPER BIRDS

I sometimes refer to these mixed-media birds as birds of poetry; you can collage text, words and bits of poems on them. Sometimes I add pockets to the birds to hold poems, text and small books. These birds make great gifts. I like to display them on the wall as a piece of art.

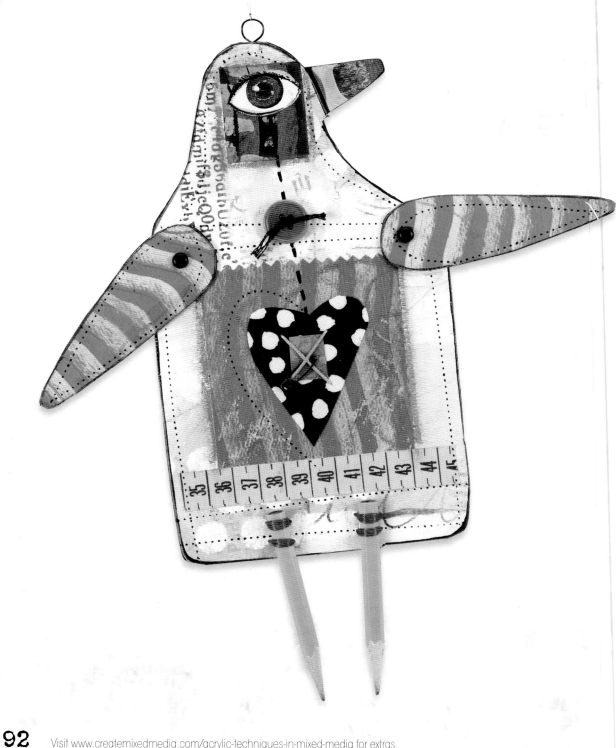

MATERIALS LIST

- Paper
- Painted papers
- Tagboard
- Small golf pencils
- Collage materials, such as papers, fabric bits or measuring tape
- Drawing materials, such as Sharpies and Caran d'Ache crayons
- Acrylic paints
- Colored brads
- Embroidery floss
- Tacky glue
- Glue brush
- Hot glue gun
- White cosmetic sponge
- Pencil
- ⅛" (3mm) hole punch
- Wooden clothespins
- Brayer
- Needle
- Scissors
- Pushpin
- Tracing wheel
- Wire
- Embellishments

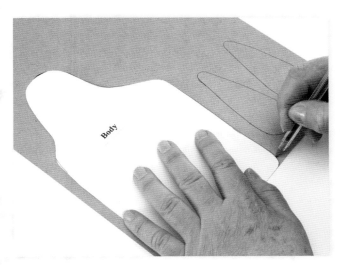

1 Cut out the bird template from the Appendix or draw a simple bird shape and wing with a pencil on a piece of paper. Trace the body and two wings on a sheet of tagboard with a pencil or pen. Cut out the shapes with a pair of scissors.

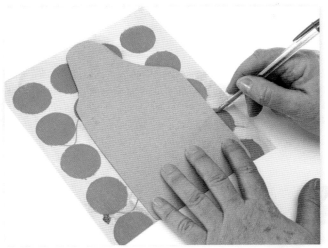

2 Using your body piece, trace and cut out two pieces of painted paper for the front and back of the bird.

Sign up for the free newsletter at www.createmixedmedia.com.

93

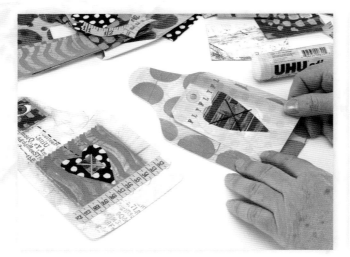

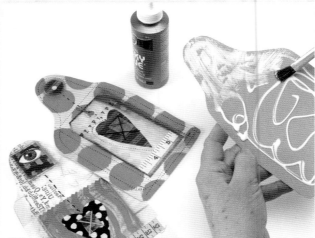

3 Collage the front and back pieces of the bird. Add hand stitching, an embroidered x, a paper heart shape, permanent marker lines and crayon marks as desired. You can also use a tracing wheel and paint to make broken lines.

4 Use tacky glue and a glue brush to adhere the front piece to the tagboard. Use a brad to secure it in place.

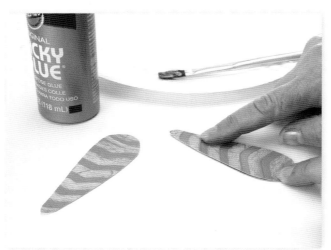

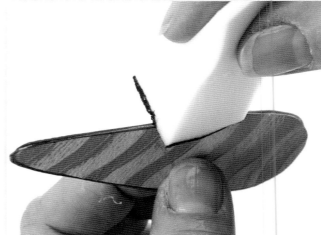

5 Trace the wing pattern four times onto painted paper. Cut out the wing shapes and glue the paper to the front and back of both tagboard wings. Use a brayer to flatten out the pieces.

6 Using a white cosmetic sponge, paint around the edges of the wings. Add traced lines with the tracing wheel and paint if desired.

Flattening Tip

If the body and wings don't flatten after you use the brayer, press the pieces between books to dry and flatten before you assemble the bird.

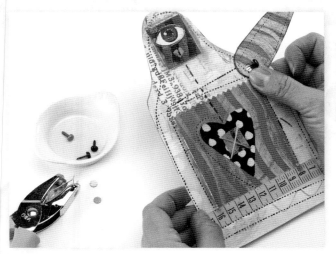

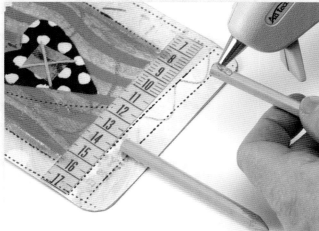

7 Use a hole punch to punch holes in the end of the wings and the shoulder part of the bird body. Attach the wings with colored brads.

8 Use a small amount of hot glue to hold the pencil legs onto the body. Let the glue dry.

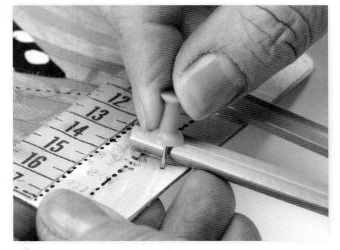

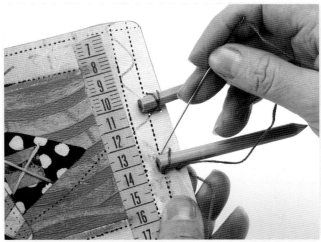

9 Prepunch two small sewing holes on each side of each pencil with a pushpin.

10 Using a large paper needle and colored embroidery floss, sew the pencils to the bird. Tie a knot in the back of the pencil to hold it in place.

Alternative Legs

For optional legs, try colored pencils with their leads dulled, sticks from nature or a small ruler cut in half.

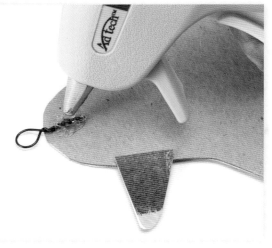

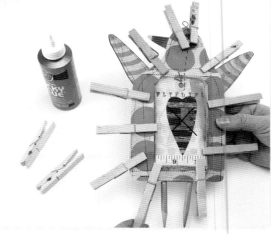

11 Glue a small wire loop and a paper beak to the back of the head with the glue gun.

12 Glue the back piece of paper to the back of the bird. Place wooden clothespins around the bird to hold it in place while drying.

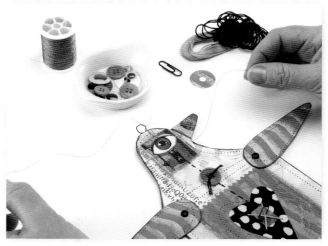

13 Paint around the edges with paint and a sponge. Embellish with buttons, safety pins, googly eyes and metallic thread.

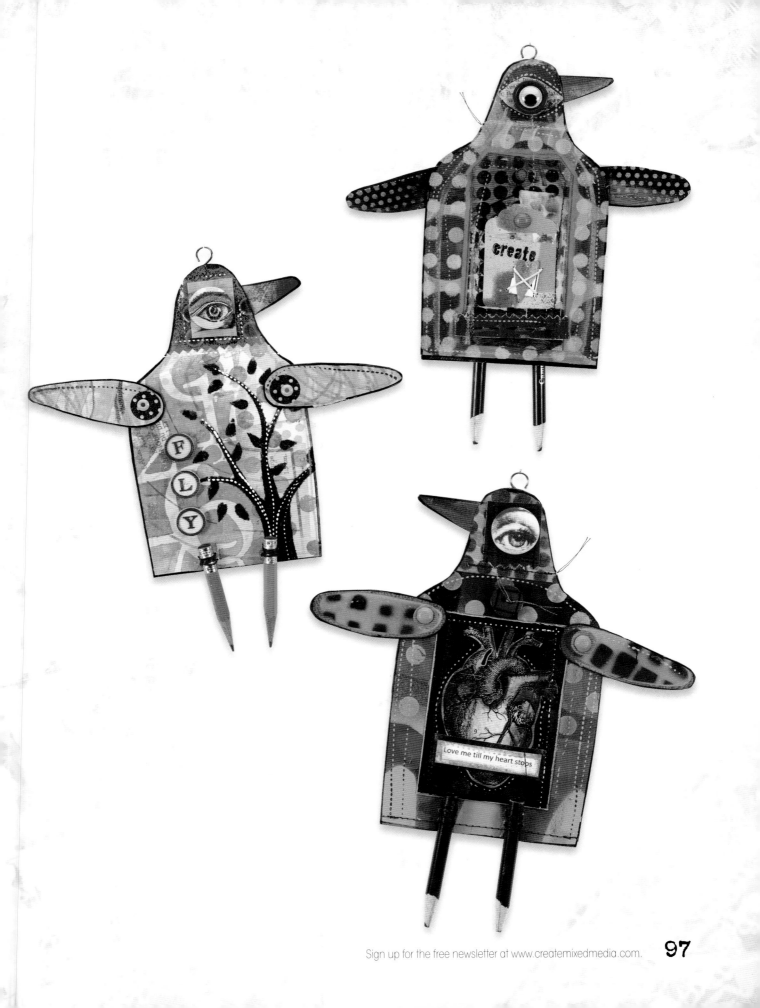

I like to purchase hardbound books at the secondhand store or dollar store. Once I get them home, I strip the pages out, saving them to paint on and use for collage. Then I use the cover to create a new book. The covered books are very sturdy, and you can add better quality paper for the pages of the book. It's a great use for discarded books that could end up in a landfill.

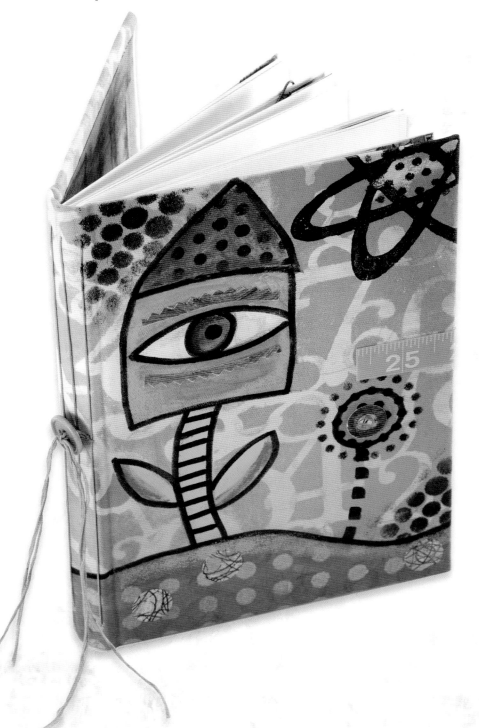

MATERIALS LIST

- Cotton duck painted canvas
- Hardbound book
- 80 lb. drawing paper
- Painted paper scraps
- Caran d'Ache crayons
- Pencil
- Acrylic paint
- Stencils
- Copic marker
- Embroidery floss
- Bookbinder's wax
- Button or beads
- Glue stick
- Tape
- Pushpin or awl
- Binder clips
- Brayer
- Bone folder
- Scissors
- Craft knife
- Large paper needle

Cotton Duck Fabric

Cotton duck is a heavy duty fabric, most commonly used for outdoor upholstery and awnings. You can purchase it in most fabric stores, and it comes in a variety of colors. I like to paint on this fabric because it has a tight weave and is durable enough to make many layers.

1 Use a craft knife to remove the pages from any hardcover book. Be careful not to cut through the spine of the book cover.

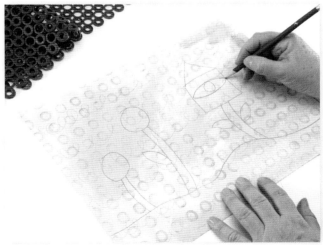

2 Cut a piece of a neutral painted cotton duck fabric to 2" (5cm) larger all the way around than the book cover. Add a crayon rubbing to the fabric, then draw a design with a pencil.

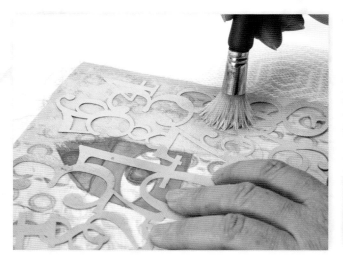

3 Fill in the design with paint and stenciling.

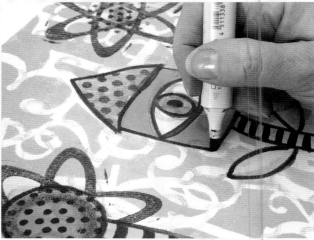

4 Outline the design with a black Copic marker.

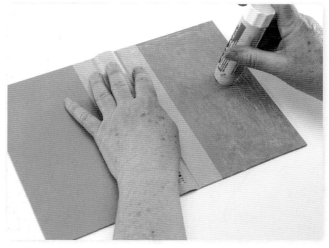

5 Using a glue stick, cover the front cover, spine and back cover of the book board with glue.

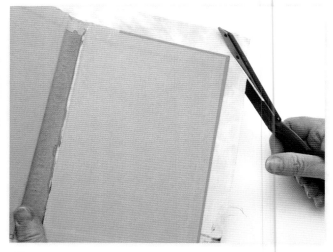

6 Place the book board on the unpainted side of the painted canvas. Press flat with a brayer. With a pair of scissors, trim off the corners to ⅛" (3mm) from each corner of the book cover.

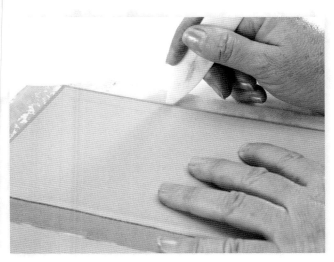

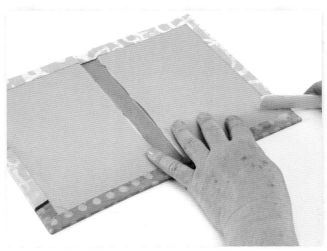

7 Use a bone folder to prescore the canvas along the edges of the book. This will make a crisper looking edge and make it easier to fold over.

8 Glue the edges of the canvas and fold the canvas over the cover of the book on all four sides. Use the bone folder to crease the canvas and secure the edges.

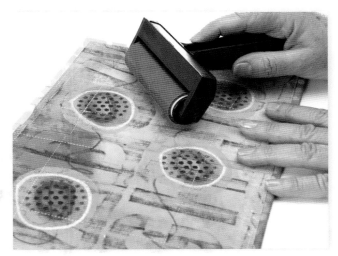

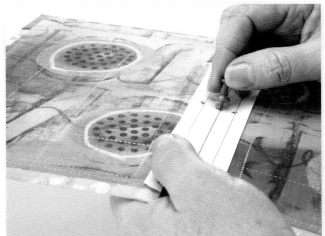

9 Cut a piece of painted canvas ½" (1cm) smaller all around than the flat book cover. Use a glue stick and glue the canvas to the inside of the book. Flatten with a brayer and let dry.

10 Cut a piece of paper to the size of the spine. To make the binding template, mark three rows of holes with three holes across each row. (See the Appendix.) Mark the bottom and top holes approximately ½" (1cm) from the top and the bottom of the spine edge. Center the middle holes between the other two holes. Tape the template to the spine and poke holes with a plastic pushpin. Remove the template.

11 Cut twelve sheets of drawing paper ½" (1cm) smaller all the way around than the book cover. Fold the sheets in half to make the pages, stacking them in three sets of four pages each. Use one row of the template to make holes along the fold in one set of pages. Poke the holes with a pushpin or awl. Repeat for each of the remaining sets of pages.

12 Measure and cut a piece of six-strand embroidery floss three times the length of the spine. Run the floss through a piece of bookbinder's wax. Thread on a large paper needle; do not tie a knot at the end of the thread.

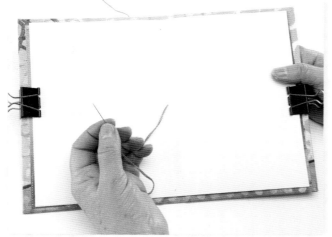

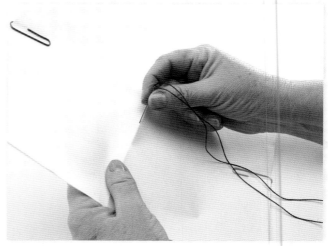

13 Use binder clips to hold the first signature in place. Bind the signature into the book, following steps 14 through 17 below.

14 Begin sewing through the middle hole from the outside of the pages (or book cover, in this case). Pull through the hole leaving a 6" to 8" (5cm to 20cm) tail on the outside.

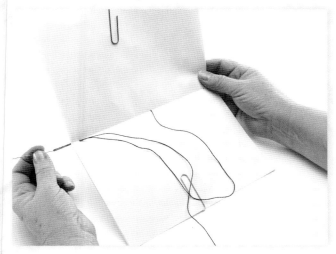

15 Turn over and sew through the top hole, from the inside to the outside, until the thread is taut.

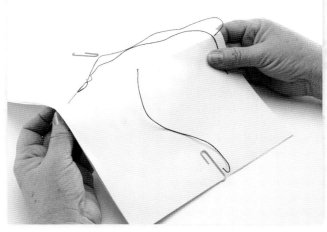

16 Turn back over and sew through the bottom hole from the outside to the inside and pull until taut.

17 From the inside, sew back through the middle hole to the outside of the book. With the long middle thread between the two loose ends, tie a double knot.

18 Repeat for all the signatures, placing each signature through a separate set of holes in the spine. Add paper strips folded in half to the edges of some of the pages.

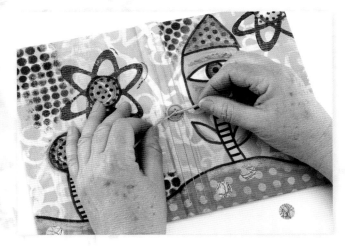

19 On the outside of the spine, tie a button or a bead to the hanging threads. Embellish with more collage, artist's crayons or more stenciling, if desired.

SLIDE PROTECTOR SHEET SCRAPBOOK

I have always been interested in photography, from developing my own black-and-white film to manipulating images in the digital age. At one point I had all my photos printed in slide format. Soon I began thinking of ways I could use the slides and slide protector sheets, as well as protectors for all sizes and types of photographs, in my mixed-media art. Now, I look for old photo albums at the secondhand store and buy them just for the plastic pockets. This project teaches you how to use some of these slide protector pockets, and it's a great way for using your "bits," too.

MATERIALS LIST

- Plastic slide protector sheets
- Paper for pages
- Painted papers, scraps and bits
- Pen, pencil or other drawing materials
- Embroidery floss
- Embellishments
- Button for closure
- Corded black elastic
- Bookbinder's wax
- Sewing thread
- Acrylic paints
- Large paper needle
- Scissors
- Sewing machine
- Tracing wheel
- Tape
- Stapler
- Awl or pushpin

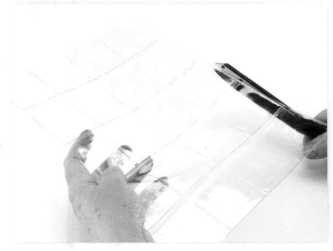

1 Use scissors to trim a plastic slide protector sheet to the desired size and trim the holes off. Here, I'm using all the rows and columns of pockets.

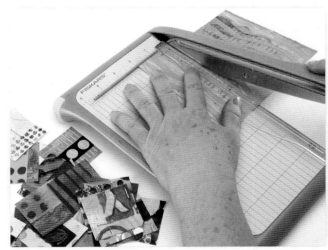

2 Collect your painted paper and fabric scraps and cut into 2" (5cm) squares. Collage smaller bits of scraps onto the squares using tape and staples to add more layers. Use a pen, pencil or tracing wheel with paint to make some marks.

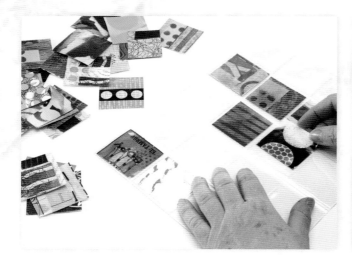

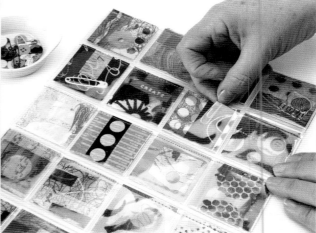

3 Begin filling the pockets of your cover sheet, front and back, with your collaged squares.

4 Add loose items to the pockets, including safety pins, paper clips, charms, buttons and googly eyes. Avoid putting hard items in the center row, as you'll be poking holes there for the binding.

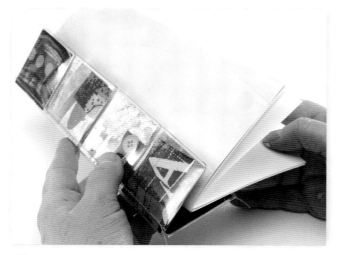

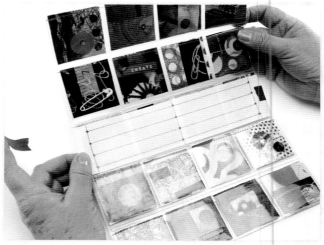

5 With a sewing machine, sew closed the openings of the pockets. This will be the cover of your book.

Cut four plastic sheets for the signatures of the book. Here I'm using four rows and two columns of pockets.

Fill and sew the pockets of the signatures as in the previous step.

Cut five sheets of paper for each signature. The size of the pages will be ½" (1cm) smaller all the way around than the height and width of the cover front.

Scribble and paint on four sheets of paper; these will be your cover sheets for each signature. Fold and stack one small slide protector sheet, one painted sheet and four sheets of paper for each signature.

6 Cut out the spine template from the Appendix for the placement of the signatures. Tape the template to the inside cover of the spine.

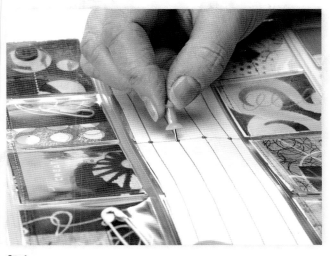

7 Punch holes at the marked spots with a small awl or a pushpin.

8 Remove the paper template and place it in the center of the inside of one of the folded signatures, lining up one row of holes in the fold. Tape or clip the template in place. Poke holes through the template and pages with a pushpin or a small awl. Repeat with all the folded signatures.

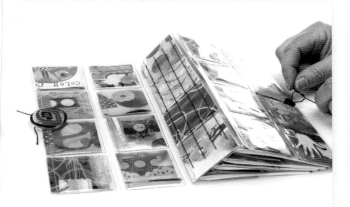

Mix It Up

You can make different sized books by cutting smaller sections of the plastic protector. Here, I've used a grouping of four pockets by two pockets for the larger book and just two pockets for the smaller books. All are bound using the pamphlet stitch.

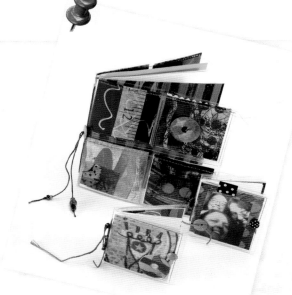

9 Sew signatures in place with waxed embroidery floss using the pamphlet stitch (see steps 13 through 18 in the Painted Canvas Altered Book project).

Hand-sew a button to the front of the book and a piece of corded elastic to the back to create the closure.

MANILA FOLDER BOOK

For books like this one, I purchase heavyweight manila folders at office supply stores; the folders are quite sturdy for the cover of a book. When I'm ready to make one or several single signature books, I just cut them up and paint them any color I want. You could also collect folders in a variety of colors and patterns and make your books with them. These books make great gifts, but are also perfect for small projects like holiday photos, recipes or notes.

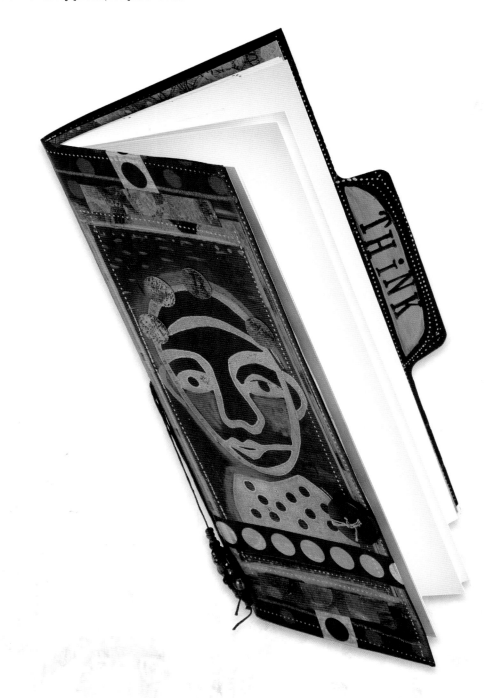

MATERIALS LIST

- Manila folder
- Drawing paper for pages
- Painted papers
- Crayons, permanent markers, colored pencil
- Acrylic paint
- Bookbinder's wax
- Embroidery floss
- Embellishments
- Foam roller
- Glue stick
- Stamps
- Binder clips
- Bone folder
- Large paper needle
- Scissors
- Paper cutter or craft knife and cutting mat
- Stencil
- Stencil brush
- Pencil
- Ruler
- Pushpin

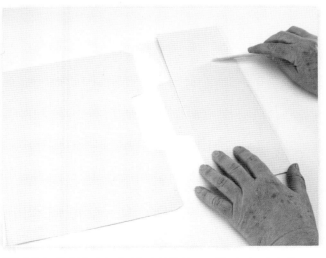

1 Cut a file folder in half at the fold. Fold one of the halves in half using a bone folder to crease the fold.

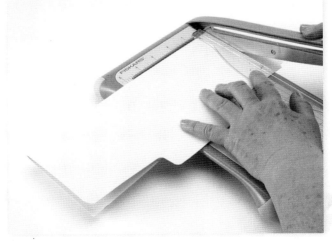

2 Trim to desired height with a paper cutter or a craft knife and a ruler. I trimmed my book to 10½" (27cm) tall.

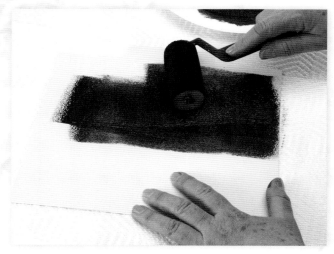

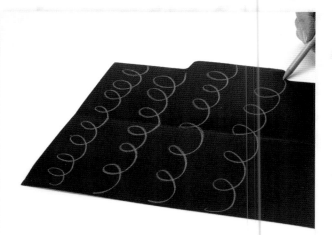

3 With a small foam roller, paint the front and back of the folder with two coats of paint. Let dry in between each coat.

4 Scribble on the inside of the cover with a colored pencil.

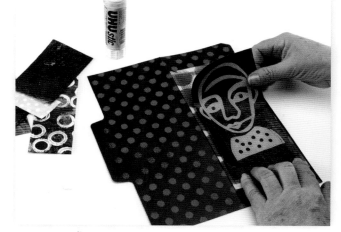

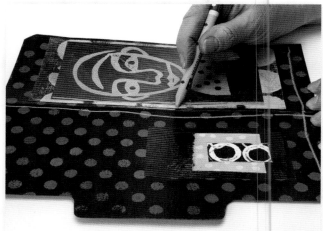

5 Stencil polka dots on the outside cover with acrylic paint and a stencil brush. Using some of your painted and stamped paper and a glue stick, collage the front cover of the book. For my project, I used a stamped image of my handmade face stamp.

6 Add traced paint lines, crayon lines and stamping to the outside and inside of the cover.

More Ideas

There are so many ways to make this book! Here are some more ideas for you to consider. Cut the pages at various widths and cover the edges with painted paper strips folded in half. Paint all the pages for the book before sewing the pages into the book. Or paint black-and-white copies for the pages of the book.

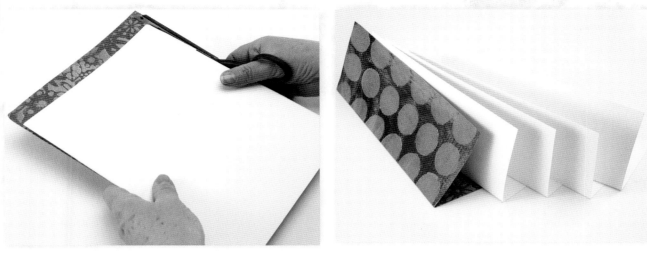

7 Cut five sheets of heavyweight white drawing paper with a paper cutter or craft knife. Cut the pages ½" (1cm) smaller all the way around than the cover of the book.

8 Paint and stencil one of the sheets of paper front and back. Let dry. Fold all the pages and the one painted sheet in half and stack on top of each other. The painted one will be on the outside of the pages.

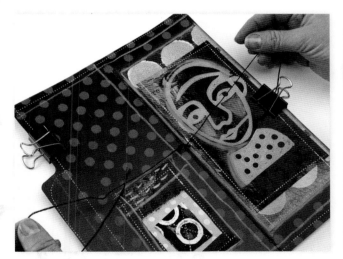

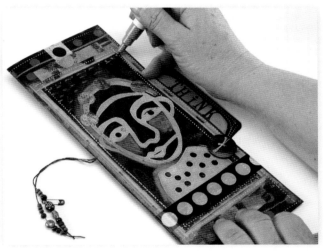

9 With a pencil and ruler, mark three holes on the fold: Mark one hole in the center and the other two holes ½" (1cm) from the top and the bottom edge. Poke holes in the paper at the marked spots with a pushpin. Center the folded papers in the cover and use a pencil to mark through the holes in the paper to the cover. Poke holes in the cover at these marks. Follow steps 13 through 18 in the Painted Canvas Altered Book project to bind the book using the pamphlet stitch. Hold in place with binder clips while you are sewing.

10 Embellish with tape, collage, beads, buttons and more drawing, as desired.

BRUSH HOLDER

With just a couple of painted canvas rectangles, you can create a super cool and unique holder for your paintbrushes, pencils or other art tools. All measurements are approximate, so you can make this any size you like to create a holder that will fit a variety of different tools. To embellish this holder, I like to create unique buttons from large wooden disks that I purchase at the craft store. You can paint and stencil the wooden buttons to match your color palette.

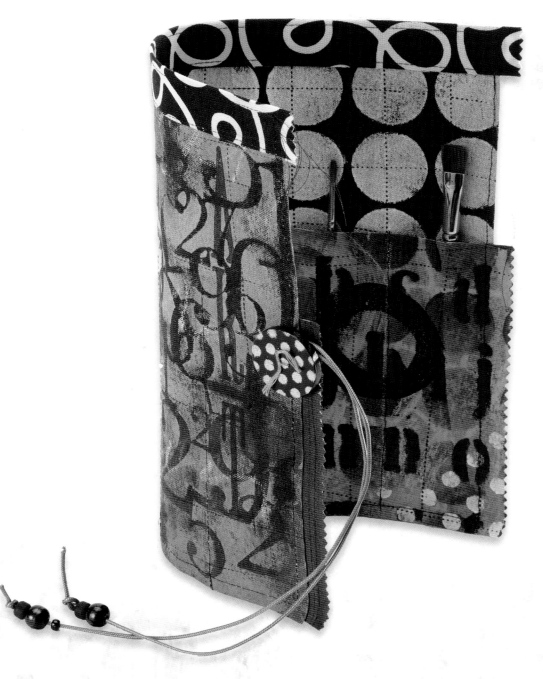

MATERIALS LIST FOR PAINTED BUTTONS:

- Painted canvas
- Thread
- 2' (61cm) cording
- Button
- Embellishments
- Tape
- Pencil
- Paintbrush
- 2" (5cm) clear ruler
- Scissors
- Pinking shears
- Sewing machine
- Acrylic paint
- Fabric

- 1½"-2" (4cm-5cm) wooden circle
- Acrylic paint
- Gloss medium
- Stencils
- Small stencil brush
- Small paintbrush
- Pushpin
- Needle and thread
- Hand drill and ⅟₁₆"(2mm) drill bit

1 Cut one piece of painted canvas 10½ " x 14 " (27cm x 36cm). This piece of canvas should be painted on both sides. Cut another piece of painted canvas 6 " x 15 " (15cm x 38cm); trim the short sides with pinking shears.

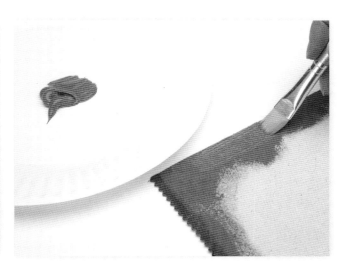

2 Paint the back side edges of the 6 " x 15 " (15cm x 38cm) piece. These painted edges will stick out past the edge of the larger piece and are for decoration only, not function.

Embellishing the Canvas

You can embellish these canvas pieces as much as you want. Try rubber stamping words and images on the painted canvas. Add hand-stitched decorative lines with colored embroidery floss. Hand-sew on buttons, beads and charms.

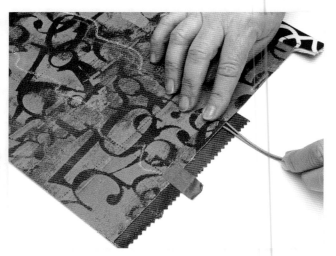

3 Cut a third 2" (5cm) strip of fabric the length of the large piece of canvas. Fold in half, and with a sewing machine, sew to the top edge of the painted canvas.

4 Place the 6" x 15" (5cm x 38cm) piece of canvas right-side down on a surface. Place the larger piece of canvas over it, aligning the bottom edges. Tape in place to hold.

Fold a 2' (61cm) piece of cording in half and tuck the loop end in between the two pieces of canvas on the outside edge. Tape in place.

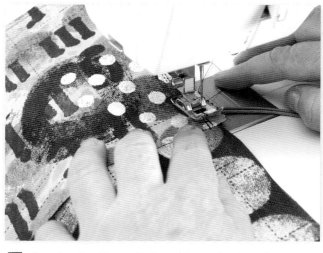

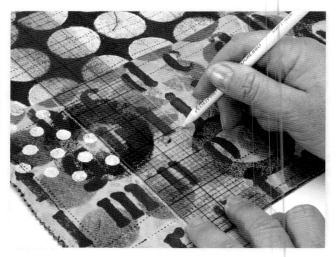

5 Sew along the sides and bottom of the smaller piece of canvas. Remove tape as you sew.

6 Mark 2" (5cm) sections with a pencil along the bottom edge. Make these same marks at the top edge of the small piece of canvas. Connect these marks with vertical pencil lines.

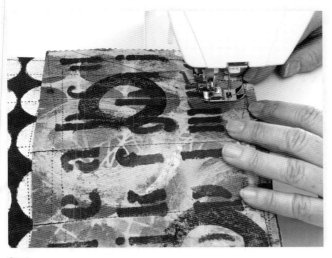

7 Sew along the marked lines to form pockets.

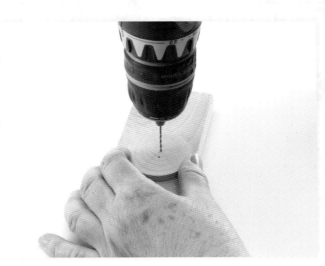

8 To make your own wooden button embellishments, use a ⅛ " (2mm) drill bit and an electric drill to drill two holes in the center of a wooden circle.

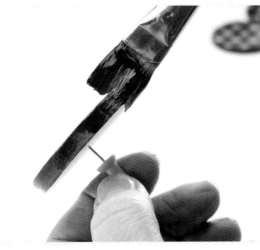

9 Push a pushpin into the back of the wooden disk to hold while painting. Use a small paintbrush and acrylic paint to paint the front, side and back of the wooden circle. Let dry.

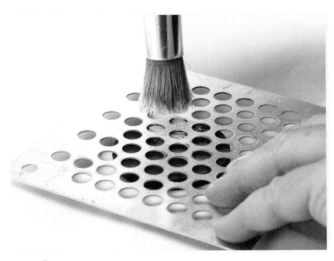

10 On the top of the button, stencil a design with another color of paint and a small stencil brush. Let dry.

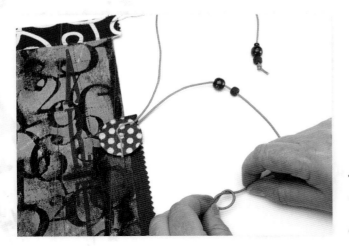

11 Using a small flat brush, apply gloss medium to the front and side of the button. Let dry.
Add the wooden button to the outside edge of the holder, stringing it onto the cording. String beads and tie a knot at the end of the cording.

PAINTED ZIPPERED BAG

These painted bags are so versatile; you can use them for art supplies, makeup or jewelry, or add a strap for a small shoulder bag. One of my tricks for sewing with heavier-weight canvas is to use painter's tape to hold the piece of canvas together instead of straight pins. I like to press my painted canvas with an iron to create a very flat surface to work with.

Visit www.createmixedmedia.com/acrylic-techniques-in-mixed-media for extras.

MATERIALS LIST

- Painted canvas
- 9" (23cm) polyester all-purpose zipper
- Jump ring
- Beads
- Fabric sealant (such as Fray Check)
- Thread
- Painter's tape
- Plastic measuring tape
- Safety pin
- Needle-nose pliers
- Scissors
- Pinking shears
- Sewing machine
- Iron
- Tape

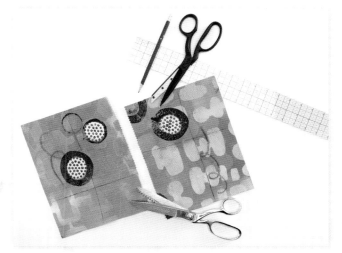

1 With a pair of scissors, cut 2 pieces of painted canvas 7½ " x 9½ " (19cm x 24cm). Use pinking shears to trim one long edge of each piece.

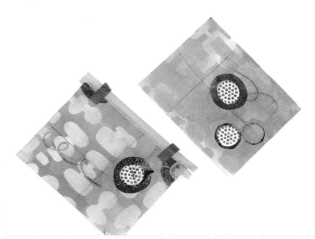

2 Lightly press the zipper with a cool iron if necessary to flatten. Tape the pinked edge of one piece of canvas to the zipper.

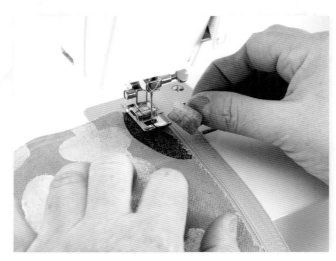

3 Sew the zipper in place with a sewing machine, removing the tape as you sew.

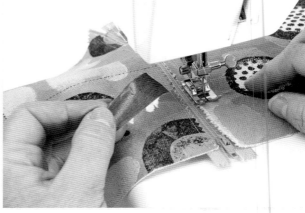

4 Tape and sew the other piece of canvas to the other side of the zipper.

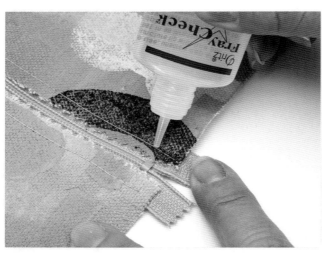

5 Use a fabric sealant to seal the raw pinked edges and the beginning and end of each seam.

Threading the Needle

To see the eye of the needle on a sewing machine for threading, hold a piece of white paper behind the eye. This makes it easier to see where to insert the thread.

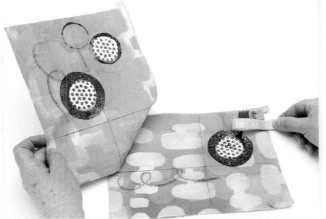

6 Unzip the zipper and place right sides together. Cut a 5" (31cm) piece of measuring tape, fold in half and tuck the loop into the inside on one side of the bag. Align the cut ends of the measuring tape to the edge of the canvas. You will be sewing over this tape.

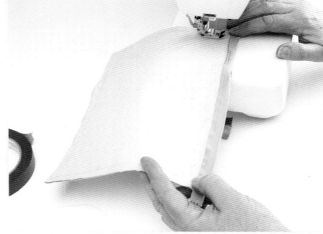

7 Tape the canvas pieces together with the measuring tape in place. Sew ½" (1cm) all the way around the two sides and bottom of the bag.

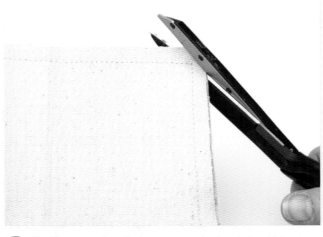

8 Trim the corners from the bag at an angle, close to the stitches, to remove some bulk from the corners.

Make It a Shoulder Bag

Add a strap and make a small shoulder bag. Instead of inserting the loop in step 6, insert one end of a strap on each side of the pouch and sew in place with a sewing machine. I use 1½" (4cm) cotton strap from a fabric store.

Sign up for the free newsletter at www.createmixedmedia.com.

119

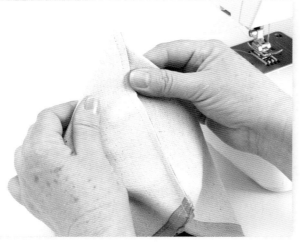

9 Fold the one bottom corner into a triangle to form a base for the bag.

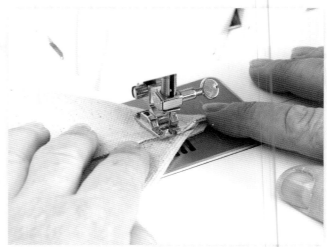

10 Sew ⅝" (2cm) from the folded corner. Trim away the excess corner about ¼" (6mm) from the stitch line. Repeat for the second bottom corner.

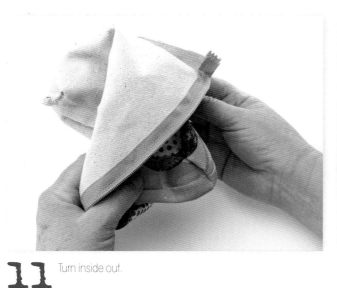

11 Turn inside out.

12 Create a zipper pull by using needle-nose pliers to open a jump ring. Attach the jump ring to the zipper and add a safety pin with some beads.

Alternative Zipper Pull

You could also use a jewelry maker's T-pin to make a zipper pull. String beads and charms on the T-pin and bend a loop at the end with needle-nose pliers to attach to the zipper.

Bags of Any Size

Vary the length of the zipper and you can make the bag in various sizes. Just trim your zipper to the length you want by cutting from the open end, leaving the zipper stopper intact for your project.

Sign up for the free newsletter at www.createmixedmedia.com.

121

APPENDIX

Paper Bird Template

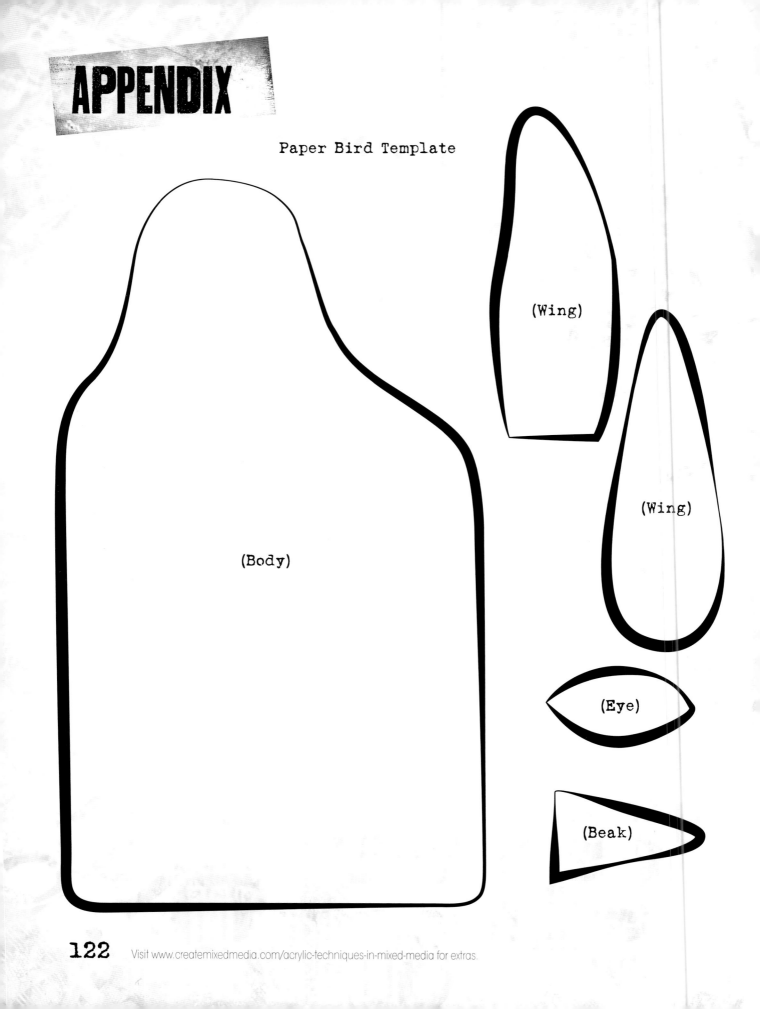

(Wing)

(Wing)

(Body)

(Eye)

(Beak)

Visit www.createmixedmedia.com/acrylic-techniques-in-mixed-media for extras.

Book Binding
Template

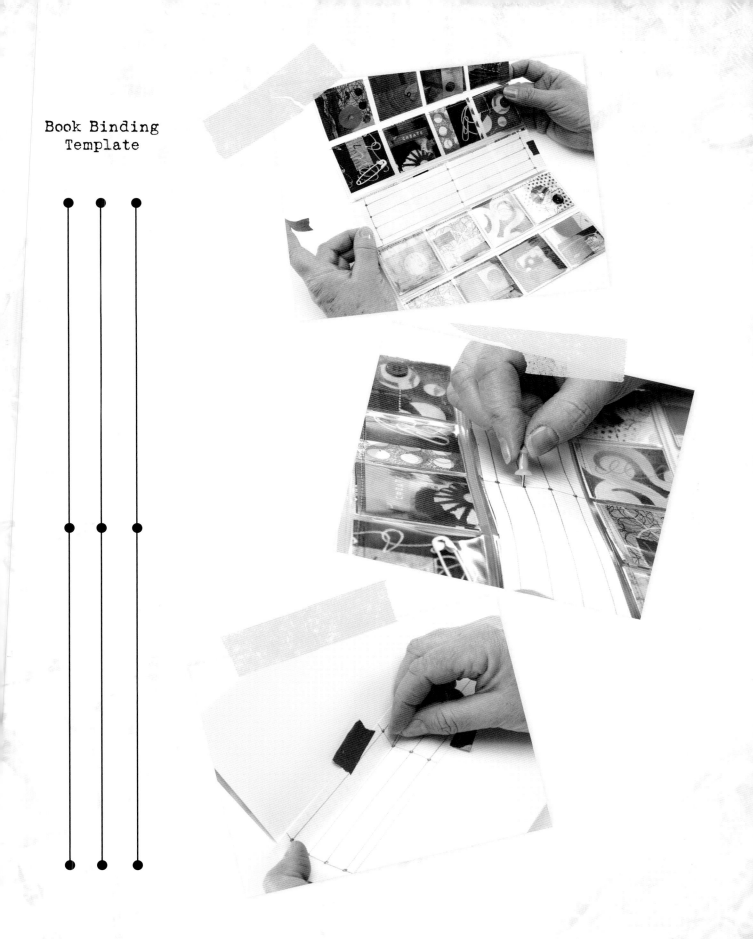

INDEX

ABOUT THE AUTHOR

About the Author

Roxanne Padgett has been creating "stuff" and making "messes" since she was four or five years old, using whatever materials she could find. She does the same thing today, but now it is called Mixed-Media Art. "I explore my creative voice through painting, drawing, collage, photography, text, journaling and textiles. I am inspired by playing with color and layering and am fascinated by what is revealed and concealed through the layering process. I enjoy sharing the creative process with others and believe that everyone is creative, not just a special few."

Roxanne teaches a variety of art classes for adults throughout the Bay Area and at art retreats around the country. In addition, Roxanne works for the Museum of Children's Art in Oakland, California as an arts educator. Roxanne's work has been featured in a variety of publications such as, *Somerset Studio*, *Sew Somerset*, *Stuffed* and *Green Craft*. She lives in Hayward, California with her husband Bryan. You can follow Roxanne and find your creative outlet at her blog, www.arthouse577.blogspot.com.

Dedication

This book is dedicated to my husband, Bryan, who has supported my creative journey since day one. He gives me great advice on projects, cooks dinner so I can work and loves my color palette. He was the one who gave me my tagline "Fear no color." Thank you for being my biggest fan and helping me to make this book a reality. To my four beautiful grandchildren, London, Ryder, Phoenix and Jax, whose creativity and love inspire me every day.

Acknowledgments

Thank you to the entire North Light team for making the entire process fun and easy. Firstly, to Tonia Davenport, for seeing the potential in my artwork. To my editors, Bethany Roa, Christine Doyle and Amy Jones, thanks for making this happen. To my photographer, Christine Polomsky, thanks for your technical expertise and generosity. To the designer of my book, Amanda Kleiman, I love the design!

Metric Conversion Chart

To convert	to	multiply by
Inches	Centimeters	2.54
Centimeters	Inches	0.4
Feet	Centimeters	30.5
Centimeters	Feet	0.03
Yards	Meters	0.9
Meters	Yards	1.1

17 16 15 14 13 5 4 3 2 1

DISTRIBUTED IN CANADA BY FRASER DIRECT
100 Armstrong Avenue
Georgetown, ON, Canada L7G 5S4
Tel: (905) 877-4411

DISTRIBUTED IN THE U.K. AND EUROPE
BY F&W MEDIA INTERNATIONAL
Brunel House LTD, Newton Abbot, Devon TQ1 4PU, England
Tel: (+44) 1626 323200
Fax: (+44) 1626 323319
Email: enquiries@fwmedia.com

DISTRIBUTED IN AUSTRALIA BY CAPRICORN LINK
P.O. Box 704, S. Windsor NSW, 2756 Australia
Tel: (02) 4560 1600, Fax: (02) 4577 5288
Email: books@capricornlink.com.au

ISBN-13: 978-1-4403-2142-9

Edited by Christine Doyle, Amy Jones and Bethany Roa
Designed by Amanda Klieman
Production coordinated by Greg Nock
Photography by Christine Polomsky

fw
media

www.fwmedia.com

NEED MORE LAYERS AND SCRIBBLES IN YOUR ART?

We've got you covered. Discover more ways to Layer, Scribble, Stencil and Stamp with the *Acrylic Techniques in Mixed Media* companion page on CreateMixedMedia.com! Have a smartphone with a QR code reader? Just scan the code to the left for more sample art by Roxanne, awesome ideas for new layering and projects. Or visit www.createmixedmedia.com/acrylic-techniques-in-mixed-media.

Easy Mixed Media Surface Techniques
Seth Apter
NORTH LIGHT DVD | an artistsnetwork.tv production

Doodles UNLEASHED
MIXED MEDIA
techniques for doodling, mark-making & lettering
trac¿ BAUTISTA

Direct vs Indirect: Two Ways of Painting in Oil
the **Artist's** magazine
Multiple-Point Perspective
Winners of the 2012 Annual Art Competition
Misty and Mysterious Learn the Secret to Tonal Landscapes
December 2012

 Follow CreateMixedMedia for the latest news, free demos and giveaways!

Follow us !
@CMixedMedia

Follow us !
CreateMixedMedia

These and other fine North Light mixed-media products are available at your local art & craft retailer, bookstore or online supplier. Visit our website at CreateMixedMedia.com!

CreateMixedMedia.com

- Connect with your favorite artists.
- Get the latest in mixed-media inspiration.
- Be the first to get special deals on the products you need to improve your mixed-media endeavors.

For inspiration delivered to your inbox, sign up for our free newsletter.